Paradise and Plumage

Paradise and Plumage *by Rob Linrothe*
Chinese Connections in Tibetan Arhat Painting

Rubin Museum of Art, New York, in collaboration with the
Frances Young Tang Teaching Museum and Art Gallery,
Skidmore College, Saratoga Springs, New York

Serindia Publications, Chicago

This catalog is published in conjunction with the exhibition *Paradise and Plumage: Chinese Connections in Tibetan Arhat Painting* held at the Rubin Museum of Art, New York, from 20 May to 22 August 2004, and at the Frances Young Tang Teaching Museum and Art Gallery, Skidmore College, Saratoga Springs, from 25 September 2004 to 2 January 2005.

Published by the Rubin Museum of Art, New York, and Serindia Publications, Chicago.

Organized by the Rubin Museum of Art, New York, in collaboration with the Frances Young Tang Teaching Museum and Art Gallery, Skidmore College, Saratoga Springs, New York.

Library of Congress Cataloging-in-Publication Data
Linrothe, Robert N., 1951–
 Paradise and plumage : Chinese connections in Tibetan Arhat painting / by Rob Linrothe.
 p. cm.
 Catalogue of an exhibition at the Rubin Museum of Art, New York, May 20–22 Aug. 22, 2004 and at the Tang Teaching Museum, Saratoga Springs, Sept. 25, 2004–Jan. 2, 2005.
 ISBN 1-932476-07-5 (Paperback)
 1. Painting, Tibetan—Exhibitions. 2. Art, Tibetan—Chinese influences—Exhibitions. 3. Arhats in art—Exhibitions. 4. Buddhist art and symbolism—China—Tibet—Exhibitions. I. Rubin Museum of Art (New York N.Y.) II. Frances Young Tang Teaching Museum and Art Gallery. III. Title.
ND1432.C58 L55 2004
759.951'5'0747471—dc22 2003023084

Front cover illustration: *Peacock with Flowers and Fantastic Rocks*. China, Qing dynasty, 17th century, ink and colors on silk. Minneapolis Institute of Arts, Minnesota. Gift of Ruth and Bruce Dayton (cat. no. 20, detail)

Back cover illustration: *Arhat: Kanakabharadvaja*. Eastern Tibet, 18th century, mineral pigments on cloth. Rubin collections (cat. no. 17, detail)

Exhibition Curator: Rob Linrothe
Exhibition Coordinator: Lisa Arcomano
Project Assistant: Carly Busta

Designer: Milton Glaser, Inc.
Composition by Susan E. Kelly, Luminant Studio, Pacifica, California
Separations by iocolor, Seattle
Printed and bound in Belgium by Snoeck-Ducaju & Zoon

Contents

Foreword

We are proud and excited to offer this visually stunning and fascinating catalog, which accompanies one of the inaugural exhibitions of the Rubin Museum of Art (RMA). As an exploration of the relationship between Chinese and Tibetan images of Arhats, it is the first of many RMA projects that will investigate the connections between the art of the Himalayas and that of other cultures.

Paradise and Plumage: Chinese Connections in Tibetan Arhat Paintings contributes to a wider understanding of the development of Himalayan art, and we are grateful to the many lenders, both private collectors and institutions, who have generously agreed to allow their works to be involved in this dialog across cultures. We would also like to thank the exhibition's curator and the author of this book, Rob Linrothe, along with the entire staff of RMA for their tireless efforts to see the museum through its opening. It is our hope that this exhibition will serve as one model for a fruitful and peaceful exchange between different cultures to their mutual enrichment.

Shelley and Donald Rubin

Acknowledgments

This exhibition could not have been contemplated without the generosity of the lenders. Many people working in galleries and museums, as well as private collectors, have opened up the collections in their care and allowed me to learn about and select works that might be matched with those in Rubin collections. It has been a pleasure to pursue this project, and it is an equal pleasure to acknowledge some of these people by name. They include Cary Liu and Karen Richter of the Princeton University Art Museum; Maxwell K. Hearn and Hwai-ling Yeh-Lewis of The Metropolitan Museum of Art, New York; Arnold Chang and Carol Conover at Kaikodo, New York; Travis A. Kerr; Valrae Reynolds at The Newark Museum; John and Berthe Ford; Navin Kumar; Robert Rosenkranz; Amy Poster of the Brooklyn Museum of Art; Christophe Mao at Chambers Fine Art; and Bob Jacobsen at the Minneapolis Institute of Arts.

At the Rubin Museum of Art, both Carly Busta, curatorial assistant, and Lisa Arcomano, manager, Collections and Exhibitions, have made uncountable contributions, including voicing encouragement, editing, organizing, and taking a thousand jobs, large and small, into their competent hands. My largest debt of gratitude goes to them. In addition, Jeff Watt, Tenzin Dharlo, Ben Brinkley, Gene Smith, Kim Ronis, Marilena Christodoulou, Patrick Sears, and Hannah Stephenson went out of their way to assist when I needed it. Milton Glaser and Katja Maas designed the catalog beautifully, while Martina D'Alton has been a pleasure to work with as an editor. Shane Suvikapakornkul contributed a great deal in his role as copublisher. Ian Berry at the Tang Teaching Museum and Art Gallery, Skidmore College, has been very generous with his curatorial wisdom and encouragement. Finally, I am grateful to Shelley and Donald Rubin for the opportunity to work with them on a unique project.

NOTES: NUMBERING, TRANSCRIPTIONS, TERMINOLOGY, AND ICONOGRAPHY

In the essay and the catalog entries that follow, I refer to works in the exhibition by their number preceded by "cat. no." Photographs appearing in the essay are designated as "fig." I also refer in the entries to relevant numbered sections of the essay. Chinese words are romanized using the Pinyin system, unless within quotations or published names of authors. Tibetan and Sanskrit are rendered in the system devised by Jeff Watt and Ben Brinkley known as RMA standard. It is explained on the Himalayan Art Website (www.himalayanart.org) under "Help." Catalog nos. 1, 4, and 5 are exhibited at RMA only. Catalog nos. 6 and 7 are exhibited at the Tang Teaching Museum only.

Unlike Tantric texts, which prescribe the visualization of the deities down to minute details, Arhat texts do not give definitive visual characteristics for the sixteen Arhats.[1] A single example is the meditation gesture shared by both Ajita and Chudapantaka. Thus, the iconography of individual Arhats has only gradually been standardized, but within several different traditions, including separate Tibetan and Chinese systems, which order them differently.[2] Because Chinese and Tibetans occasionally tried to mesh or rectify each other's systems, the situation is extremely complex. The fact that there was considerable scope for individual innovation and creativity had the unintended effect of aggravating the confusion of iconography. Sorting out the different traditions found in existing Arhat painting, to the degree that it is now possible, is an important task, but it is not attempted here. Individual identifications of Arhats are not assumed to be definitive, and those assigned by owners of works on loan are not challenged. The exhibition and catalog focus on general issues found in images of all sixteen Arhats, such as the settings, the figure types, and the material culture illustrated in the paintings.

[1] "As to the difference in attributes and mudras [between Chinese and Tibetan images of Arhats] . . . there was evidently no fixed rule in representing the Arhats" (M.W. de Visser, "The Arhats in China and Japan," *Ostasiatische Zeitschrift* 10 [1922/23]: 101).

[2] The main Arhat text (discussed in the introductory essay) gives the names of sixteen Arhats, the number of their retainers, and their residences; "however, it does not specify their individual iconographical features. This lack of specificity suggests that the portrayal of [Arhats] was free at the beginning of the [Arhat] painting tradition. Although eventually their iconography was vaguely codified, it was never firmly established, leading to a critical problem in the identification of [Arhats] in visual images" (Masako Watanabe, "Guanxiu and Exotic Imagery in Rakan Paintings," *Orientations* 31, no. 4 [2000]: 35).

Between China and Tibet

ARHATS, ART, AND MATERIAL CULTURE

Arhats are enlightened beings who are also very much human. They are considered to have been either the actual disciples of the Buddha or followers who lived soon after his time. It is believed that the Arhats elected to remain on earth, mostly unseen, living in remote locales. Occasionally they manifest themselves in order to bless or to help, and to preserve and transmit the Buddha's teachings. They are often mistaken for ordinary monks.

In 1408, the Fifth Karmapa, Deshin Shegpa (1384–1415), returned to Tibet laden with presents and honors after a two-year sojourn in Nanjing, the early Ming dynasty (1368–1644) capital. He sent reciprocal gifts to his host in China, the Yongle era emperor Chengzu (r. 1402–24), among which was a set of paintings depicting the sixteen Arhats.[1] Only ten years later, in 1418, the Gelugpa Lama Shakya Yeshe (1355–1435) also returned from a long journey to the Ming capital with gifts from Emperor Chengzu. These included a set of silk woven *tangkas* of the sixteen Arhats for his teacher, Tsongkapa (1357–1419), and a set of sixteen sandalwood Arhats for Shakya Yeshe himself.[2]

What prompted this particular choice of subject matter for gifts traveling between China and Tibet? Had the Karmapa seen the set of Arhat paintings painted at the Chinese court sometime during the Yongle period (cat. nos. 4, 6) and thus knew of the imperial interest in the theme of Arhats? Or, in fact, did these gifts stimulate or help to confirm the interest of the Yongle emperor in the theme? While it is not possible to answer those questions definitively, these examples illustrate the cultural exchange between the Chinese court and Tibet.

The Fifth Karmapa and Shakya Yeshe were only two among several Tibetan religious leaders whose reputations and prestige were appreciated at the Chinese court, and who, between the fifteenth and eighteenth centuries, were invited to visit the Chinese court out of regard for their spiritual powers and attainments. Besides the Fifth Karmapa and Shakya Yeshe, the most famous of the early Ming visitors included Lama Kunga Tashi (1349–1425) of the Sakya lineage[3] and, during the Qing dynasty (1644–1911), the Fifth Dalai Lama, who came to court in 1652, and the Sixth Panchen Lama, who came in 1780.[4] There were innumerable other occasions of gift giving between emperors of the Ming and Qing courts of China and Tibetan teachers or their representatives. Gifts of spiritual value and luxury objects were included with invitations, with letters of acceptance or

decline, as rewards, as presentations, and as return gifts.

The consequences of these exchanges are often considered mainly religious and political, but it is doubtful they were confined to these spheres. They were just as noteworthy in the realm of culture. Although religious paintings and sculpture were the most natural objects to be reciprocated in a patron-priest relationship, Tibetan visitors of refined tastes were inevitably taken with the beauty of the secular painting traditions of China: the bird-and-flower paintings, the portraiture, the ink and blue-and-green landscapes. These paintings, along with Chinese luxury objects such as exquisite textiles, sophisticated porcelain and stoneware ceramics, precious objects made of jade and coral, and hardwood furniture, flowed into Tibet through trade and from presentations made by the imperial court. Recent inventories of Tibetan monastery treasuries reveal plentiful examples of high-quality Chinese porcelains, jades, and textiles.[5] The numbers are all the more significant given the widespread destruction of Tibetan monastery holdings during the Cultural Revolution (1966–76).

Substantive exposure to high-quality Chinese art began in Tibet during the Yuan period (1279–1368). While simultaneously continuing to value and absorb the Newari (Nepalese) art style, Tibetan artists started to participate to a noticeable degree in the Chinese cultural horizon. Yet the exchanges were made in both directions. Tibetan visitors and well-wishers offered precious objects as gifts to China, including Buddhist images and relics, dyestuffs, coral, rhinoceros horns, and metalwork such as armor and swords.[6] During the Ming dynasty, one of the most obvious ways Tibetan ideas affected Chinese art was the iconography of court-produced Buddhist imagery, and this continued into the Qing period.[7]

In Tibet, the impact of Chinese art and material culture on post-fourteenth-century art was profound. In terms of both subject matter and style, the Tibetans' paintings reveal their intimate knowledge of Chinese

luxury goods such as ceramics, textiles, and furniture. The same is true for Chinese painting styles of all kinds, including religious painting, court or academic painting, and literati ink painting. Familiarity is even demonstrated in Tibetan paintings by one of the most arcane and elevated expressions of Chinese literati tastes, the scholars' rock.

The present exhibition, *Paradise and Plumage: Chinese Connections in Tibetan Arhat Painting,* celebrates and explores this artistic exchange. It takes the theme of Tibetan Arhat painting as a concise lens through which to conveniently view the wider ramifications of the interaction. Yet, since the subject matter, and even in some cases the compositions, were shared by both Tibetan and Chinese painters, the Arhat theme helps to focus attention on elements that appear common to Tibetan and Chinese art or are clearly distinctive to Tibet, even when they later surface in Chinese paintings. Examining the circulation of motifs, compositions, and modes of representation also reveals the creative reassignment of meaning when Tibetan artists appropriate aspects that may derive from older Chinese traditions. *Paradise and Plumage* does not intend to show that Tibetan artists were derivative or creatively dependent on China. Rather, the aim is to highlight a measure of material culture valued in common, even if used in differently nuanced ways. The final work in the exhibition (cat. no. 27) is uniquely Tibetan and unlike other paintings in the show. It would never be mistaken for a Chinese painting, although it displays many elements that are just as clearly associated with Chinese painting and luxury goods: the plumage of exotic birds, Arhats wearing golden brocades suspended by a ring at their left shoulders, inky entwined tree trunks, lacquered-wood enclosures, and modeled rock forms built up of small units that tilt on their axes. Nevertheless, the painting is visibly Tibetan.

A final aim of the exhibition is to simultaneously, and perhaps contradictorily, call into question the sharp distinctions between

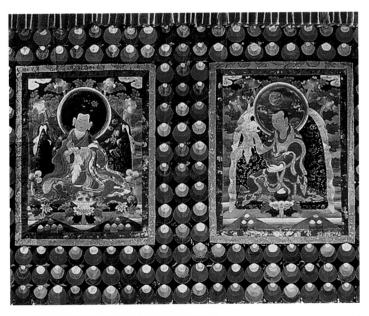

Figure 1. Silk appliqué of Arhats in Rongwo Gongchen monastery, Amdo Rebgong, Tibet, 20th c.

Figure 2. Dharmatala, fragment of a *tangka* painting (mineral pigments on cloth) in a chorten in Karsha, Zangskar (India), ca. 14th c.

what we call Chinese and Tibetan art. The fact is, sometimes it is hard to tell the difference. If a Tibetan artist, working in China, uses a silk ground for an Arhat painting that is adapted to Tibetan tastes from a Chinese model, which itself may have been inspired by Tibetan imagery, is it Tibetan or is it Chinese? If, by contrast, an artist uses the cotton ground generally found in Tibet to paint an Arhat according to a Tibetan composition,

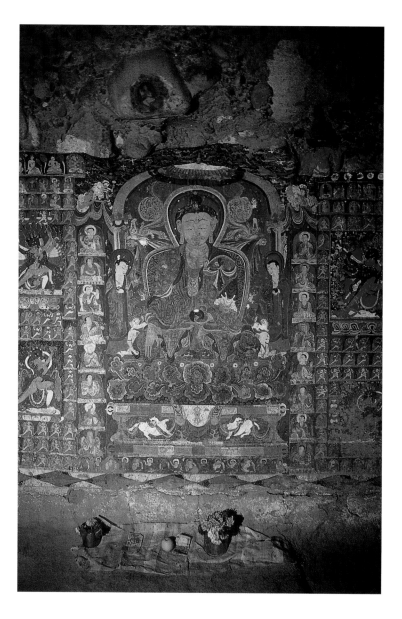

Figure 3. Mural painting in cave of Shakyamuni with sixteen Arhats and Dharmatala, Saspol, Ladakh (India), ca. 15th c.

1

ARHATS: HUMAN MONKS, ENLIGHTENED IMMORTALS

The Arhats are considered either the actual disciples of the Buddha or the tonsured followers of his teachings who lived soon after his time.[8] For this reason, depictions of Arhats show them dressed in the robes of Buddhist monks. Arhats are understood to be fully realized.[9] They gained enlightenment by following the Buddha's *dharma* (teachings on the nature of reality) and by meditating. It was to the Arhats that the Buddha entrusted his teachings for preservation and transmission. Through their solitary meditations leading to enlightenment, Arhats are believed to have acquired great longevity, if not immortality, as well as miraculous powers to help unenlightened beings. They remain on earth, mostly unseen, living in remote sacred locales. Occasionally they manifest themselves in order to bless or to help and are often mistaken for ordinary monks. In their forest or mountain hermitages, they have both monastic disciples and lay personal attendants in their retinues, as can be seen in the paintings exhibited. Arhats have been described as both enlightened, yet simultaneously very human, beings:

> From the spiritual point of view they are regarded either as actual emanations of the Shakyamuni Buddha himself, or as great beings who are blessed by the Buddha's grace so as to bring extensive benefit to the many different kinds of devotees. . . . From the mundane point of view they are regarded as ordinary mortal beings who were born into different castes of society. . . . By their endeavors, which were both intensive and constant, they all attained, without exception, the rank of [Arhat].[10]

Along with the Buddha, Arhats are historically among the earliest venerated figures in the Buddhist tradition, and their cult spread

but using brushwork we credit to Chinese painting, with a Tibetan inscription on the back, can we be sure it is (not) Tibetan? The artist's ethnic identity, the place of production, materials, painting style, and largely unrecorded history of the evolution of compositions make it challenging to attribute some of these paintings with confidence.

wherever Buddhism traveled, from India to Japan. Known in China as Lohan, they were particularly popular there, and their numbers expanded to five hundred. The Arhats are especially inspirational to monks and nuns as successful models who continue to observe all monastic rules and vows. In Chinese Buddhist vernacular religion, they are miracle workers who can bestow benefits of all types.

Within Tibetan monastic practice, the *puja* (ritual) of the sixteen Arhats surrounding Shakyamuni is performed daily, as part of a brief morning liturgy, by monks from Sakya, Kagyu, and Gelug traditions.[11] During the one month in late spring or early summer commemorating Shakyamuni's enlightenment, more extensive rituals are performed by monks in their remembrance of the historical Buddha. This explains why many contemporary Tibetan monasteries have sets of Arhat paintings, brocades, or color reproductions (along with Shakyamuni, the four guardian kings, and the two Arhat lay-attendants Dharmatala and Hvashang) hanging in the main assembly hall (Dukang) all year long (fig. 1).[12]

Today, the remembrance of the sixteen Arhats with Shakyamuni is believed to have entered Tibet with Atisha (982–1054) and Shakyasribhadra (d. 1225), Sakya Pandita's teacher from Kashmir.[13] Although the Arhat remembrance is especially beneficial for monks, an influential sutra also emphasizes the positive response of the Arhats to lay believers sponsoring feasts for monks or in other ways assisting monasteries. It was translated into Chinese in the mid-seventh century and sometime later into Tibetan. This text is titled *A Record of the Abiding of the Dharma Spoken by the Great Arhat Nandimitra*.[14] The Tibetan texts that inspire current Gelug practice include a description of the *puja* practice by the Second Dalai Lama, Gendun Gyatso (1475–1542), another by the Fifth Dalai Lama, Lobzang Gyatso (1617–1682), and two by Dharmabhadra.[15] A set of

Figure 4. Detail of fig. 3 depicting an Arhat and Dharmatala (left).

Figure 5. Two Arhats, fragment of a *tangka* painting (mineral pigments on cloth) in a chorten in Karsha, Zangskar (India), ca. 14th c.

related texts connected to the Arhat practice, including an explanation for sprinkling water on images of the sixteen Arhats, is credited to Kachen Yeshe Gyaltsen (1713–1793).[16] The latter texts have had the greatest influence on the prayers, rituals, and arrangements of the sixteen Arhats in large and small monasteries in Tibet, according to Dagyab Gelugpa Rinpoche.[17]

The Chinese textual tradition was based on Nandimitra's *Record of the Abiding of the Dharma*. This seminal text, as well as an essay by the fourteenth-century Tibetan scholar Buton (1290–1364), originally featured sixteen Arhats.[18] However, these were expanded to eighteen and over time came to number as many as five hundred in China. As the great Italian scholar and traveler Giuseppe

Figure 6. Dharmatala (bottom) and unidentified Arhat from a mural painting in Guru lhakhang shrine near Phyang monastery, Ladakh (India), ca. 15th c.

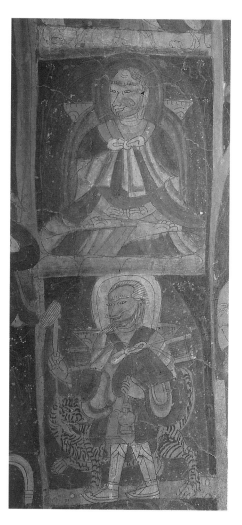

Tucci pointed out, the Tibetans also independently expanded the set of paintings to eighteen by the addition of two "attendants," or "patrons," known as Dharmatala and Hvashang, who were not originally included in the Chinese set of sixteen or eighteen.[19] Although Dharmatala appears to have early roots and is certainly incorporated into the grouping well before the fifteenth century, Tucci suggests that Hvashang might be a later addition.[20] The contemporary scholar Stephen Little has shown, however, that in the mid- or late fourteenth century, the two appear in a Tibetan set of Arhat paintings of unknown origin that exhibit knowledge of Chinese painting conventions.[21] The pair also appear in a sketchbook of a Newari painter named Jivarama dated to 1435, by which time they must have been part of the standard set at least in Nepal and central Tibet.[22] Complicating the issue is that both of the images—Dharmatala with a tiger escort and a backpack of Buddhist texts (figs. 2, 4, 6), and Hvashang, big-bellied and laughing, accompanied by children—appear separately with other identities in Chinese art. For instance, the image that Tibetans use to depict Dharmatala is nearly identical to the Chinese one at Dunhuang identified as the Tang-dynasty (618–906) pilgrim Xuanzang.[23] The appearance of Hvashang in Tibet is derived from Chinese images of the big-bellied Chan (Zen) Budai, popular since the Northern Song dynasty (960–1126); moreover the name "Hvashang" (pronounced "Hashang" by central Tibetans) is borrowed from the Chinese word for "monk."

Yet a group of sixteen Arhats plus Dharmatala, but omitting Hvashang, is also known and seems to be at least as early as the fourteenth century. These sixteen Arhats plus Dharmatala are found, for example, in cave paintings of that approximate date in Saspol, in Ladakh (far western ethnographic Tibet, now incorporated into India's political borders), where little or no direct Chinese influence would have been felt (figs. 3, 4). In this mural, which is found on the back right wall of the main cave, two columns of eight Arhats flank Shakyamuni Buddha. They are dressed in undecorated but multi-hued monks' robes. A diminutive Dharmatala is painted at the far right of the register beneath the Buddha (fig. 4). The tiger is at his feet and he carries a backpack of books, a vase, and a fly whisk. He is shown as a layman, his long hair tied into a chignon. Although in modern discourse Dharmatala is sometimes mistakenly referred to as an Arhat, his lesser status as an attendant is recognized in this painting by his smaller size compared to the sixteen Arhats. Other versions record his peripheral status by placing

him at the end of a register, as in a fragment of a similarly dated painting from Karsha in Zangskar, also in Indian western Tibet (fig. 2).[24] In other examples, he is found at the bottom of a column of Arhats, as in the fourteenth- or fifteenth-century Dharmatala from the Guru Lhakhang shrine near Phyang monastery in Ladakh (fig. 6). It is notable that three depictions of Dharmatala from western Tibet made about the same time show such divergence. Though his attributes are standardized, whether he is an old man with a white beard (fig. 6), has long hair tied into a chignon (fig. 4), or wears a turban (fig. 2) seems to depend on artistic whim. At any rate, it shows the iconography at this early stage was still being worked out.

The Saspol painting (figs. 3, 4) and the Karsha fragment (fig. 5, a detail from the same fragment as figure 2), depict Arhats as idealized monks. This mode of Arhat "portraiture" is one of the two alternatives, beginning no later than the ninth century and continuing into the present, shared by both China and Tibet.[25] This first mode emphasizes the Arhats' human nature by giving them an appearance correlated to dignified, ordinary, though idealized monks of China or Tibet. "What emerges here is the perfected ideal of all monks—the combination of inner strength and spiritual concentration with outward physical beauty and grace."[26] They wear monks' robes traditional to Tibet or China. The later Arhats exhibited here, whether painted by a Chinese or Tibetan, appear quite sinicized in appearance (cat. nos. 4–7, 15, 24, 25, 27). Occasionally, the Tibetan painters favor an ethnically Tibetan-looking Arhat (cat. nos. 9, 17).

If the first mode emphasizes the idealized but natural, the second mode underscores the Arhats' supernatural aspects by giving them a grotesque, sometimes caricatured appearance, exaggerating physiognomic characteristics. Foreign features seem to recall the Indian origins of Arhats, but through a stereotyping East Asian lens. Examples in the exhibition show the darkened skin of Indians, over-

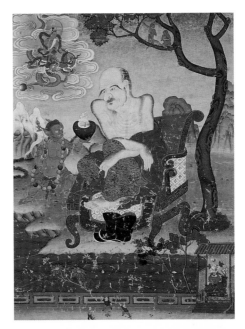

Figure 7. The Arhat Bakula, *tangka* painting (mineral pigments on cloth), Tibet, 19th c. Rubin Collections p1996.12.2; Himalayan Art Website Item 259.

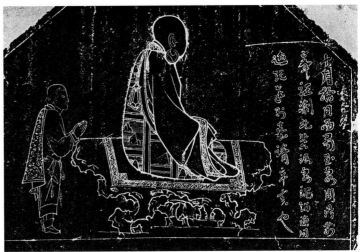

grown eyebrows, dark beards, and extremely long earlobes (cat. nos. 1, right; 2, 3). (The overgrown eyebrows and beard also appear in the western Tibetan Arhat in fig. 6.) This type tends to look rather scruffy or haggard, with eccentrically shaped heads (cat. no. 1, left), as if his body has paid the price for his intense efforts to become enlightened. The result is individualized, expressive portraits, which, in a roundabout way, also reinforce

Figure 8. Bodhidharma from a stele in Shaolin Temple, Henan (China), late Northern Song dynasty. Rubbing on paper of inked stone; entire stele.

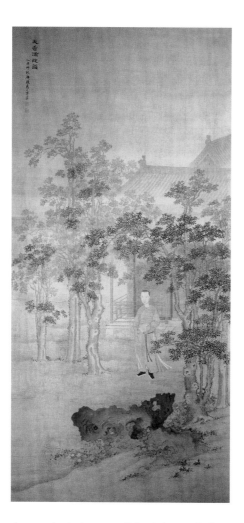

the ontological status of the Arhats as beings
in and of this world.

In most sets of paintings since the fifteenth
century, whether painted in China or Tibet
(but based largely on Chinese paintings),
both modes are present: dignified, idealized,
and sinified; and grotesque, haggard, and
foreign.[27] Examples from Tibetan sets with
strong Chinese connections are included in
the exhibition: catalog no. 3 shows the some-
what scruffy, rugged, and hairy Arhat that
is very close to the earlier Chinese Arhat of
catalog no. 2. Catalog no. 15, from the same
set as no. 3, shows the more austere, aris-
tocratic Chinese ethnic type. (See also the
appendix, which depicts twelve out of the

original sixteen Arhats with two attendants
and the four Directional Guardians from the
same set. More than one of the Arhats is in
the eccentric foreign mode.) However, in a
late Tibetan set that shows greater indepen-
dence from Chinese examples, the Arhats
as a whole are more uniformly dignified in
appearance and much less ethnically marked
as strange or foreign. This set of woodblock
prints from Dege Parkang monastery, though
recarved in the twentieth century, was based
on earlier models.[28]

2

EARLY ARHAT IMAGERY:
THE RAW AND THE COOKED

In the two earliest surviving East Asian Arhat
paintings, from the ninth century, both
modes of appearance are evident, and, inter-
estingly, one of them is done by a Tibetan art-
ist. In a colored drawing on paper retrieved
by the early twentieth-century explorer Sir
Aurel Stein, from the western Chinese cave
site of Dunhuang, a seated Arhat in a monk's
robe holds a bowl and a monk's staff.[29] He
is definitely in the dignified "civilized" or
"cooked" mode, with a canopy above him
and a large oblate nimbus behind his head.
A Tibetan inscription identifies the subject
as the Arhat Kalika, and the artist as
"Do-khon-legs," otherwise unknown. What
strikes observers is that he appears "as a rather
ordinary Chinese traveling monk" and rather
"unassuming."[30] It is datable to the early to
mid ninth century, thus predating the earliest
surviving examples of the grotesque mode of
Arhat imagery.

Although the set of paintings surviving in
the Tokyo Imperial Collection attributed to
the famous painter Guanxiu (832–912) and
depicting the grotesque version of Arhats may
not all be by him, they are accepted as early
and accurate copies, which give a faithful
sense of his vision if not his hand or brush.
His Arhats are "raw," knobby, and distorted in

physiognomy, tormented, startled, or stern in demeanor. They have many of the characteristics associated with both mountain recluses and foreigners, such as big noses, overgrown eyebrows, protruding foreheads, and sometimes darkened skin. These "archaic and wild" features were preserved even in the much later versions that were made for the Qianlong emperor (r. 1736–96) in the eighteenth century, as well as in the Shengyin temple in Hangzhou where the emperor encountered them.[31] The Guanxiu type is immediately recognizable even in Arhat paintings made much later in Tibet, such as a painting in the Rubin collections (fig. 7), done a millennium after Guanxiu painted. Two of the paintings in the exhibition show a somewhat diluted version of the Guanxiu idiosyncratic Arhat (cat. nos. 2, 3).

By the early twelfth century, both types of Arhats, the ordinary and the grotesque, were already recognized and contrasted. As the contemporary art historian Amy McNair points out, the catalog of the imperial collection under Northern Song Emperor Huizong (r. 1100–1126), the *Xuanhe huanpu,* dated 1120, contrasts Guanxiu's "weird Indians whose grotesque features expressed their struggle for enlightenment" with another Chinese artist's Arhats "as contemporary Chinese monks."[32] Both types were kept alive in Chinese painting between the tenth and twentieth centuries.[33] Both are found in Tibet as well. However, the trends in contemporary Tibetan and Chinese Arhat painting point in different directions. The popularity in China of the five hundred Arhats, each with its own distinctive and often bizarre trait, has led to an exaggeration of the grotesqueries of the Guanxiu type.[34] By contrast, many recent sets of Arhats produced in Tibetan monasteries—and not imported from China—show the more ordinary type. This is the case with the woodblock set from the Dege Parkang monastery cited in note 28 and with the appliqué Arhats hung inside an assembly hall at the Rongwo Gongchen monastery of Amdo Rebgong (fig. 1).

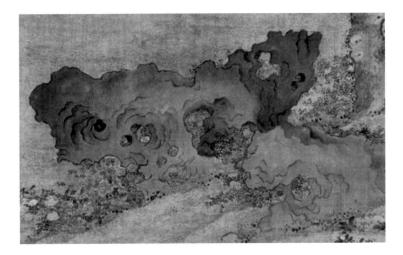

3

Figure 10. Foraminate garden rock, detail of fig. 9.

PLUMAGE: THE ARHAT MENAGERIE

The landscapes, blooming flowers, and exotic fauna featured in many Chinese and Tibetan Arhat paintings are meant to evoke pristine outdoor settings that, like the Arhats themselves, are both of this world and tantalizingly inaccessible. The landscapes are paradisiacal in their lapidary beauty and otherworldly coloring, far from the commonplaces of everyday life. Yet it is always possible to imagine these places as no farther than somewhere beyond the next mountain range. Arhat landscapes differ from those of the afterlife's Pure Land Buddhist paradises, stocked with phantasmagoric jewel-trees, crystal streams, and the palatial mansions of the Buddhas and bodhisattvas. The Arhats dwell on this earth, even if their retreats are remote and hidden from vulgar view.

In such lonely places, exotic birds, normally shy of human contact, strut and preen unconcerned in front of the Arhats (cat. nos. 19, 27). Even lions, as they pad lightly through these protected retreats, recognize a tranquillity unbroken by the presence of an Arhat (cat. nos. 4, 5). Those most skittish of woodland creatures, antlered deer, lie down contentedly at the base of the Arhat's seat (cat. nos. 24, 25), while a tiger melts, purrs,

and curls his paw distractedly as an Arhat strokes him (cat. no. 3).

Chinese non-Buddhist court paintings and textiles, such as the ones exhibited here (cat. nos. 20–23), also picture these fantastic birds and beasts in an outdoor setting. In this context, which, for want of a better description, is more secular and less sacred than that of Arhat painting, the scenes conjure up imperial pleasure gardens furnished with exotica from around the imperial realm and beyond. Like rulers everywhere, Chinese emperors delighted in receiving tributary gifts of animals from foreign lands, and these ended up in the imperial garden preserve. During the Song period, the animals documented in the imperial preserves included lions, silver pheasants, peacocks, and halcyon kingfishers, quite close to the animal inventory in the Chinese paintings and textiles in *Paradise and Plumage*.[35] Chinese imperial parks were originally for hunting and other types of pleasure, but they had clear overtones of the sanction of an authority founded on political power and the mandate of heaven. In the Chinese ideology of imperial rule, impersonal cosmic forces manifested approval of the emperor

through nature. These signs of heaven's blessing were known as *ruiying*, or "auspicious responses."[36] Among favorable portents and signs were the unexpected appearance of birds and wild animals. Cranes, such as those painted in catalog no. 23, are deeply resonant in Chinese culture as *ruiying* and also as harbingers of longevity and immortality, it being believed that they could live for hundreds of years. Some of these birds and beasts would innately recognize the imperial presence by appearing unafraid before him. By the same token, even the most dangerous of wild animals acknowledged the emperor's heaven-ordained dominion over all and submitted passively to his presence and gaze. Such paintings (cat. nos. 20, 22, 23) thus provide us an "emperor's-eye view" of the imperial garden.[37]

There is sedimentary evidence in Arhat paintings of hierarchical distinctions projected onto relations among humans and with the natural world. Since this evidence appears in both Tibetan and Chinese Arhat paintings, these distinctions were apparently common to both cultures. The first aspect is hierarchical scale, in which the Arhat in Chinese and Tibetan painting (or for that matter, the emperor in Chinese court painting) is shown much larger in size compared to attendants or disciples. This is a standard convention so well accepted in East Asian Buddhist paintings, as well as in court portraiture, as to be unremarkable. Nevertheless, it is another convention shared by Tibetan and Chinese art, one that is maintained into the present.

Certain motifs also seem to reflect an intrinsic distinction between the Arhat and his attendants, which corresponds to that observed in the Chinese ideological system between an emperor and his courtiers. For example, in catalog no. 3, the Arhat (like an emperor) fearlessly pets the head of the alert but submissive tiger, while the monk on the right watches the tiger warily and the young servant hides behind the trunk of the tree. Similarly, in catalog no. 19, the Arhat

watches impassively as the peacocks dance in front of him, while a servant boy surreptitiously observes the peacocks (or us?) from behind the doors, as if afraid they might fly away were they to see him. In catalog no. 17, a dragon bursts onto the scene in a cloud of mist, holding up a tray on which a vase overflows, making a lake of water. The Arhat watches calmly, while his two disciples appear shaken, one clasping his brow in disbelief. These are playful additions, which not only enhance the pleasure of the viewer, inserting a kind of psychological narrative into the paintings, but also call attention to the act of viewing itself. They create surrogates within the painting for viewers who share a sense of wonder about the miraculous events portrayed. At the same time, these motifs may carry within them a deep-structure memory of the response of natural and supernatural beings to spiritual presences. It is this kind of appropriate response—of the animals, and even the flowers, which seem to burst into bloom in the presence of the Arhat—that sanctifies the space. The Arhat, in turn, must be acknowledged as responding to the landscape setting, for it is he who recognizes this rock, this tree, this stream, choosing this place for his retreat.

Figure 12. Detail of carved outer border on stone passageway at the Juyong Guan, Northern China, ca. 1336.

4

PARADISE: ARHAT UTOPIAN SETTINGS

The rocks and the trees that surround the Arhat are carefully chosen to match the Arhat theme of enduring virtue, remote from the dusty commerce of daily life. The large pine tree, a convention appearing early in Chinese Arhat painting, has branches that create a canopy for the Arhat or Arhats seated below. It frames the composition and sometimes acts as a *repoussoir*, that is, a contrast between foreground and background to increase the illusion of depth. This basic form is featured in the majority of the Arhat paintings in the exhibition, both Chinese and Tibetan (cat. nos. 1–7, 13, 24, 25), including the earliest (cat. no. 1). Pine trees, like the Arhats, are associated with extreme longevity and with transformation and magic—tortuously bent and gnarled, they begin to resemble dragons.[38] Since the Arhats are believed to have lived from the time of the Buddha, remaining mostly unseen in pure and remote areas (occasionally manifesting themselves unrecognized to help the sincere), pine trees are the Arhats' true natural world counterparts.

Likewise, it is no accident that rocks and boulders, sometimes of an exotic form, are scattered throughout the Arhat landscapes.

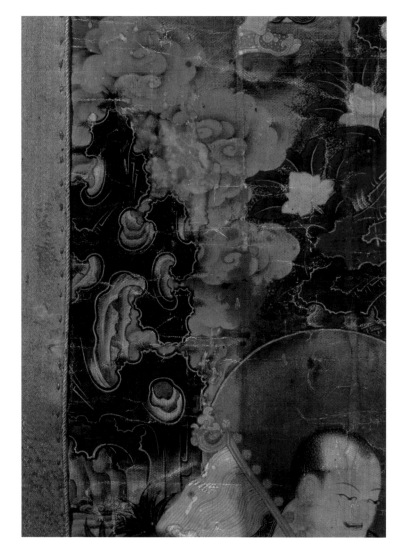

Figure 13. Foraminate rock, detail of an Arhat painting (mineral pigments on cloth), Tibet, 18th c. Rubin Collections F1998.10.3, Himalayan Art Website Item 640.

Just as auspicious birds, beasts, and flora were recognized as *ruiying,* or auspicious portents, so too were rocks.[39] In condensed and miniature form, they suggest both huge scale and the powerful natural forces that created them. Exotic rocks were highly prized for these features and were written about and collected in Chinese gardens and houses (cat. nos. 16, 18). Although originally it may have been the magical, philosophical, and microcosmic qualities of rocks that were appreciated, in time it was increasingly their abstract qualities that were noted.[40] They became the subject of an extensive literature of appreciation and collection.[41] According to one Chinese writer:

> The objects that are the purest quintessence of Heaven and Earth are found among rocks; penetrating the Earth, they take on strange forms. . . . The big ones are worthy of being set out in a garden; in a house, the little ones are placed on stands or tables.[42]

Among the paintings of the exhibition, large garden rocks are spectacularly depicted in catalog no. 20, and one can understand why such rocks would have so great an appeal. Though probably enhanced by skilled carving, ideally these rocks were formed by the action of water over millennia, and particular regions became known for their distinctive rocks. The perforations, hollows, or cavities were read as caves, the classic meditation sites of Arhats and Daoist immortals. A seventeenth-century scholar uses another standard analogy, comparing these strange stones with the mythical islands of the immortals, Penglai and Fanghu. He compares seeing a fine rock to "a stroll with the immortals."[43] In a Buddhist context, the fantastic rocks were compared to a Pure Land paradise.

The connotations of mysterious caverns and mountain-dwelling immortals are found on an early stele at the Shaolin monastery in northern China. It depicts Bodhidharma, the Indian Arhat-like meditator who is credited with bringing the Chan (Zen) school to

Frequently, a flat-topped boulder is covered with an animal skin or patterned cloth and used as a seat for the Arhat (cat. nos. 1–7, 9, 13, 19, 24, 25, 27). Other rocks make a convenient table or stand on which to place a book, vase, or incense burner (cat. nos. 6, 7, 13). Still other rocks act as backrests or foreground decoration. However, these are not "merely" decorative. Since the majority of these rocks were rendered in the blue-and-green manner, their sometimes strange shape, perforated or cusped in outline, has an exotic appeal.

northern China in the late fifth or early sixth century when he settled at the Shaolin monastery (fig. 8). Very much like the Arhats in the exhibition, Bodhidharma sits on a patterned rug or mat that has been thrown over a deeply undercut perforated rock. He wears an elaborate robe, which depicts the mountainous isles of the immortals rising up out of the ocean. Behind him is an attendant, possibly Huike, who waited patiently for years for the teachings while Bodhidharma meditated, facing a wall.[44] The attendant is reverential, like those in later Arhat compositions; he is also a bit of a rustic in need of a haircut and with less than noble facial features. (For comparable images of attendants, see catalog nos. 4, 5, 8, 25.) This important stele paralleling the Arhat image has been dated by Chinese scholars to the late Northern Song period.[45] It provides a crucial link between Guanxiu's tenth-century grotesque Arhats seated on weathered but not perforated rocks and the early Ming Arhats.

Interestingly, Buddhist temple gardens, where the association with the sacred mountains of Buddhism—Meru, Kunlun, Potalaka, and so on—would have been strongest, may have played an important role in the popularization of these rocks in China. Craig Clunas points out that many of the most famous and imitated of garden rocks belonged to Buddhist temples: "It is possible that the vogue for these rocks owes something to their presence in temple gardens, where they were deemed to impart an otherworldly appearance redolent of the Western Paradise." And he noted "the intriguing possibility of a central role for Buddhist symbolism in the popularization of garden rocks," although this must remain speculation.[46]

By Ming times, strange rocks had become an indispensable item for an upper-class garden in China. What are known as "tray landscapes" or "scholars' rocks" were regularly placed on the desks of literati or on special stands in their studies. One of the most prized types had cavities suggestive of caves and was complex in structure. These "foraminate"

Figure 14. Scholars' rock in incense burner, detail of an Arhat painting (mineral pigments on cloth), Tibet, 18th c. Rubin Collections F1998.10.3, Himalayan Art Website Item 640.

Figure 15. Scholars' rock in incense burner on altar table, detail of a *tangka* painting (mineral pigments on cloth) of an unidentified lama, Tibet, 19th c. Rubin Collections P1999.10.2, Himalayan Art Website Item 836.

rocks, one group of which came from the region known as Taihu, were "originally formed by the corrosion of limestone by acid salts when that region lay under an ocean," but then were further enhanced by sculptors.[47] Gradually, these rocks were divested of most of the overtly religious connotations, but they retained a generalized metaphysical meaning. They were grafted to Chinese notions of virtuous reclusion and the pure

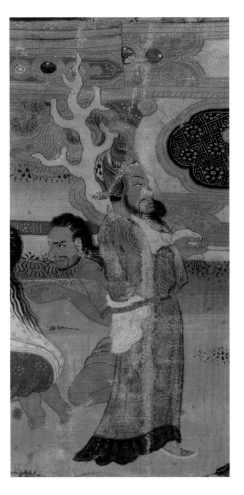

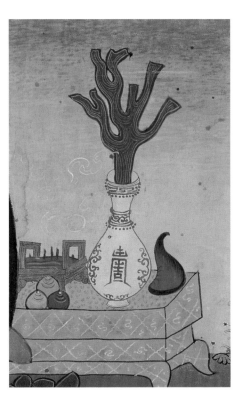

remoteness of undisturbed nature. To appre-
ciate gardens and rocks, one must have "hills
and valleys in the breast."[48] That is to say,
although most people lived in increasingly
urbanized spaces, strange rocks allowed one
to fantasize a very different kind of life in
remote mountains by pure streams. This
is surely the point of an elegant portrait
from the early Qing, dated by inscription
to 1685 (figs. 9, 10). The central figure, the
noted Manchu poet and scholar Singde
(1655–1685), stands before a well-appointed
pavilion in a garden setting.[49] In the boldest
area of color, a complex foraminate garden
rock dominates the foreground.

A luxury object, a commodity to be
bought and sold, the tray landscape was

paradoxically a sign of an inner cultivation
and taste that cannot be bartered. In China,
tray landscapes (such as the one depicted in
the lower left corner of catalog no. 15; see also
figure 11) became emblems of one's unfilled
aspirations, one's affinities to an ideal life
in nature.[50] Scandalously high prices paid
for rocks were reported during the Ming
dynasty.[51] Manuals of taste covered rocks
critically. One rare type of stone, which had
great appeal but was condemned as "vulgar"
by the literati cognoscenti, were mountain-
like rocks of semiprecious stone.[52] A Song-
dynasty record excoriates an official from an
earlier dynasty, because his wealth

> threatened to overthrow the dynasty. He had
> acquired a *shih-lü* [malachite] rock at the
> price of a thousand pieces of gold. Nature had
> formed it under stresses so that it resembled
> a mountain.[53]

A scholars' rock included in the exhibi-
tion (cat. no. 16) not only helps to link the

exotically colored rocks in Chinese and Tibetan Arhat paintings with the taste for these rocks in the Ming dynasty but also makes a literal connection to the blue-and-green style of painting. It is a specimen of azurite, the mineral that Tibetan painters often used to create the blue and the green pigments in the paintings.[54]

Why do these rocks appear so frequently in Arhat paintings? It seems clear that, as was the case with pine trees, Arhats and strange stones shared characteristics. It was recognized that the one reflected qualities of the other. Voluntary reclusion, longevity, antiquity, purity, and a kind of simultaneously natural and supernatural elemental force all converged in the stones and the Arhats. The allure of the Arhats was not much different from the fascination with miniature gardens and scholars' rocks, or for that matter, with landscape painting, which after all was closely linked to actual gardens, mountains, and streams.[55] All of them conveyed a desirable sense of the ineffable made tangible.

At a relatively early period, these perforated rocks became widely depicted in Tibeto-Chinese and Tibetan art. The stupa platform known as the Juyang Guan was built in the late Yuan period, circa 1336, to mark out the passage through the Great Wall north of Beijing. It is an example of art made in China by Mongol patrons with Chinese artists working in a Tibeto-Newari style. On the panels of the four Guardian Generals, and on border panels, honeycombed rocks are clearly depicted (fig. 12). Examples in Tibet itself are not so early. Despite the many Chinese motifs on the Gyantse Kumbum murals of the first half of the fifteenth century, including a type of blue-and-green modeling to indicate caves or mountains, I have yet to find examples of independent scholars' rocks or perforated garden rocks of any kind.[56] They are, however, present in the Arhat drawings found in the Newari sketchbook mentioned earlier dated to 1435.[57] Probably in the late Yuan period, as part of a great influx of Chinese painting motifs, methods, and manners,

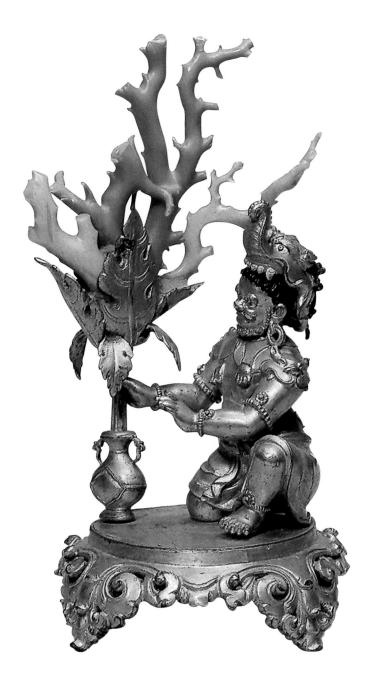

Figure 18. Wealth deity with coral tree (gilt metal and coral), Ming dynasty. preserved in Norbulingka Summer Palace, Lhasa.

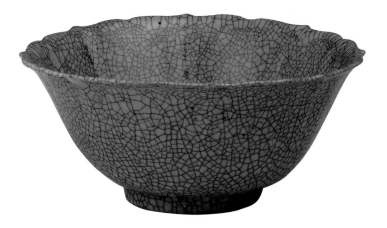

Figure 19. Foliate-rim cup, *ge*-ware, Southern Song dynasty.

garden and scholars' rocks entered the inventory of Tibetan painting. The many Tibetans who traveled to Yuan and Ming China would have developed knowledge, experience, and appreciation for scholars' rocks. These rocks were incorporated into the imperial gardens and palace environs to which Tibetan teachers such as the Fifth Karmapa, Shakya Yeshe, and others were invited. They also would have encountered them on visits to Chinese Buddhist monasteries in the towns along the way to the Chinese capital. These Buddhist monasteries are believed to have played an important role in developing and popularizing scholars' rocks, and their influence on Tibetan visitors should not be underestimated. Finally, scholars' rocks are prominent in Chinese paintings and textiles depicting Arhats and other non-Buddhist subjects, including gardens (for example, catalog nos. 20–23), and Tibetan teachers and artists had many opportunities to acquire such works of art. It is not surprising, then, that today scholars' rocks appear in Chinese artwork preserved in Tibetan monasteries (fig. 26). The ultimate, irrefutable evidence for Tibetan contact with these wondrous stones are the plentiful and spectacular examples in later Tibetan Arhat paintings of garden and scholars' rocks (fig. 13).

While garden rocks are not at all unusual in Tibetan Arhat and other types of painting after the fifteenth century, large tray landscapes such as the one in the lower left corner of catalog no. 15 (fig. 11) are less common. However, a number of miniature tray landscapes are found in later paintings, with scholars' rocks set into incense burners, and arranged on tables in front of seated Arhats and notables, next to flower vases, coral, and other offerings (figs. 14, 15).[58] Often a wisp of smoke makes it clear that these were functioning incense burners. They frequently took the form of wide-bodied tripods, as in catalog no. 11, and were not necessarily used for the stick incense with which we are generally familiar. Rather, the censers appear to be packed with sand. The miniature rocks were placed upright into the sand, and possibly powdered or compressed cone incense was lit and placed within the rocks. When the lit pieces of incense were set into the hollows of the tiny rocks, the smoke rising from the holes created the illusion of mist and clouds rising from mountain valleys.[59] This conceit, of incense floating out of ornamental rocks resembling mists rising from mountain cavities, is attested as early as the Song dynasty, when the famous literati Su Shi (1037–1101) "is known to have installed an incense burner in the hollows of a rock that he named 'Cave Paradise of Miniature Being,' . . . so that smoke would seep into its hollows and emerge through its holes."[60] Given the weight of scholars' rocks, the methods of transport, and the distance between the capitals of Ming and Qing China and the main centers of painting culture in Tibet, it is no surprise that the most common form of the scholars' rock is also the most miniature: almost pocket-sized. Based on the representations in painting, they would have been about the same scale as the turquoise "treasure offering" (cat. no. 26), which, along with coral (cat. no. 12), is a related type of wondrous stone.

5

TREASURE OFFERINGS: CORAL AND CERAMICS IN ARHAT PAINTINGS

The "coral trees" found so frequently in Arhat and other types of Tibetan painting, are analogous to the tray landscape (cat. nos. 13, 17). In Tibetan painting, they are even more widespread than scholars' rocks. The associations with coral have deep roots in the past. As early as the first millennium of the Common Era, coral trees like catalog no. 12 were being brought to China as trade objects via India from as far as the western Mediterranean. Both sea and land routes crossing Central Asia were used.[61] Coral, along with gold, silver, lapis lazuli, crystal, and pearls, was one of the *sapta ratna,* or seven precious objects, which Buddhists are encouraged to offer to Buddhist images.[62] In a later Tibetan painting, the memory of coral as precious tribute brought by foreigners is recalled by the exotic-looking king bearing a hefty limb of coral (fig. 16). More typically, coral trees are depicted placed in vases, some made of transparent glass[63] and others of Chinese blue-and-white porcelain (fig. 17), and placed on a table next to other offerings of treasures. Preserved in the Norbulingka, the summer palace in Lhasa of the Dalai Lamas, is a metalwork image of a *makara* (sea creature) offering up a vase into which an actual coral tree, much like the one in the exhibition (cat. no. 12), is inserted (fig. 18). The figure is referred to as a god of wealth.[64]

Regarding Chinese ceramics, furniture, and textiles, unambiguous evidence is found in later Tibetan paintings, and there are actual examples in the inventories of existing monasteries in Tibetan areas. Many fine porcelains and textiles made their way to Tibet and were treasured there. Tibetan artists incorporated them into all kinds of compositions, especially portraits of living or deceased teachers, and Arhat paintings. In both types of Tibetan paintings, these precious objects

Figure 20. Snuff bottles, semiprecious gems, and other objects inset in the wall of the reliquary chorten of Kadam Gyatso, Rongwo Gongchen, Amdo Rebgong, 20th c.

Figure 21. Snuff bottles, detail of fig. 20.

Figure 22. Cinnabar-lacquer table, detail of Arhat Kanakabharadvaja *tangka* painting (mineral pigments on cloth), Tibet, 17th c. Rubin Collections P1990.1.1, Himalayan Art Website Item 33.

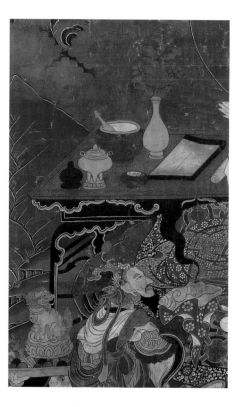

lend an air of refinement, taste, and perhaps even status, for a visit to China was often reserved for the higher echelons of Tibetan monks and teachers and usually resulted in impressive titles and, of course, valuable presents. For example, in a letter sent to the Ming Yongle emperor in 1408, Tsongkapa mentions having received a number of gifts from the emperor, including two porcelain bowls.[65] Another historically documented instance is from the eighteenth century, when the Qing Qianlong emperor sent to the Seventh Dalai Lama (Gyalwa Kalzang Gyatso, 1708–1757) ceramic vases, bowls, and basins decorated with enamel glazes.[66]

Catalog nos. 4 and 5 depict acolytes of Arhats holding fine porcelain drinking bowls in lacquer (cat. no. 4) or in metalwork (cat. no. 5) cup-stands. Both cup and stand are of a distinctive Chinese model. In catalog nos. 6 and 7, broad-bellied vessels reminiscent of Shang- and Zhou-period *gui* (ritual grain vessels) are used as incense burners, placed on

rocks beside the Arhat. The attendants are adding charcoal or incense to the vessel. Although it is difficult to determine whether the painted incense burners are intended to represent metal or porcelain, their color and shape resemble the stoneware tripod censer included in the exhibition (cat. no. 11). This tripod censer is a light olive-green glazed stoneware, probably from northern China, from the Yaozhou kilns.[67] Several other paintings in the exhibition also feature Chinese vases in the background (see cat. nos. 13, 15, 19). Fine Song porcelains are known to have been collected in Tibet, such as the *ge*-ware crackled-glaze cup with a foliate rim that has been identified as a Chinese cultural relic preserved in Tibet (fig. 19).[68]

The fine late Ming *hu* vessel with ring handles from the Brooklyn Museum of Art (cat. no. 14) is exactly the sort of Chinese temple–vase that Tibetans would have prized.[69] The spread of blue-and-white ceramics was famously wide, the demand being particularly strong at the courts of the Ottomans and Safavids, and eventually throughout Europe.[70] Tibet was surely not exempt from this taste. An inscription on the lip of the *hu* vessel documents that it was made during the Wanli period (1573–1620). Ming blue-and-white ceramics from an earlier reign period, the Xuande (1426–35), close in time to the Yongle-period paintings (cat. nos. 4, 6), are also preserved in Tibet. Some even have Tibetan inscriptions showing that they were made especially for presentation or marketing to Tibetans.[71] Such wares were familiar enough in Tibet to capture the interest of artists and become part of their repertoire. This is shown by the painted blue-and-white vase (fig. 17) bearing a coral tree decorated with a stylized Chinese character (a version of the character for "longevity").

Since Chinese porcelains have been preserved in Tibet from the Song dynasty onward, it is not surprising to find Qing-dynasty porcelains in Tibetan monasteries.[72] Therefore, a wide temporal and typological range of actual Chinese ceramics was avail-

able for Tibetan artists to incorporate into their paintings. At the same time, certain conventions for "precious Chinese porcelain" most likely began to be passed along in artist workshops, and over time these became as important as the actual models. Except for Tibetan portraiture, "painting from life" was not a typical operating procedure for artists.[73] The appearance of Chinese objects in a painting is no more a sign of ownership by the artist or patron than is the appearance of deer or phoenix. Instead, it implies more generally that there was contact and a certain degree of familiarity with these imported objects. It suggests the Chinese ceramics carried sufficient cultural weight to mean that their addition to a painting indicated the importance and stature of the main theme—Arhat or Lama. Their presence also reflects the desire on the part of the person or institution that commissioned the work to honor the deity or teacher with idealized objects that they might not actually be able to afford.

In that sense, the painting becomes something like a mandala-offering, in which one envisions offering glorified treasures to the deity. This is relevant not only to porcelains but to all the objects discussed here. The analogy becomes sharper when it is understood that the mandala-offering incorporates some of the same substances that are offered to the Arhats. Shantideva describes offerings including flowers, fruits, jewels, "clouds of incense," canopies and umbrellas set with jewels, "gem-encrusted pitchers of water," and "garlands of costly gems."[74] Patrul Rinpoche (1808–1887), a famous Dzogchen master of eastern Tibet, points out that "The offering piles placed on the mandala base would ideally consist of precious stones: turquoises, coral, sapphires, pearls and the like."[75] Dilgo Khyentse (1910–1991), one of the great teachers of the twentieth century, explains in his aptly named introduction *The Wish-Fulfilling Jewel* that an offering has an inner and outer aspect. The outer involves placing seven traditional offerings on an offer-

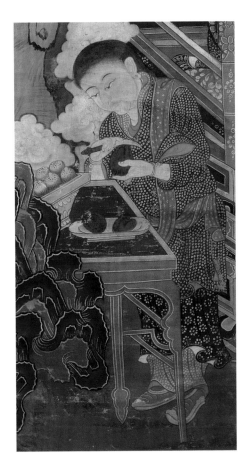

Figure 23. Cinnabar-lacquer table, detail of Arhat Vanavasin *tangka* painting (mineral pigments on cloth), Tibet, 17th c. Rubin Collections F1996.22.2, Himalayan Art Website Item 480.

ing stand. Both the objects and the act of offering are significant:

> Through our power of concentration we can offer the vast display of all phenomena. . . . This means that we make an offering of the entire universe, not in an ordinary but in a glorified form. For example, mountains, ordinarily splendid, are here made entirely of gold, silver, coral, jewels, and all kinds of precious substances; forests are lush with wish-fulfilling trees; and lakes and rivers are filled with *amrita,* the nectar of immortality. We offer not only these things, but also all we see around us that is pleasing or beautiful, such as gardens and parks, flowers, birds, and animals. . . . All of this we offer to Guru Rinpoche and his retinue of buddhas and bodhisattvas, thereby accumulating great merit.[76]

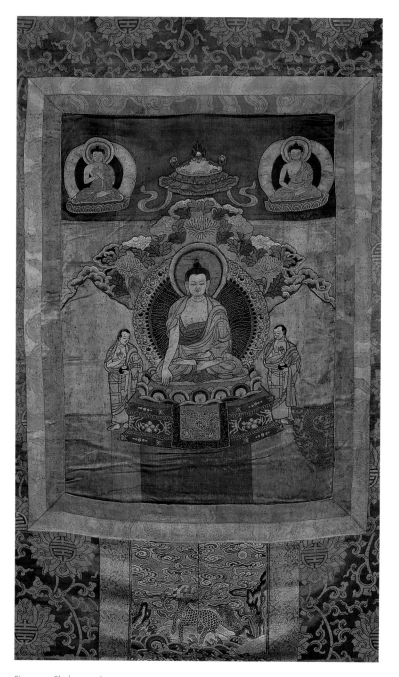

Figure 24. Shakyamuni silk appliqué *tangka*, Qing embroidered silk rank badge sewn into the lower brocade mounting, Tibet, 18th c. Rubin Collections c2003.19.2, Himalayan Art Website Item 65223.

This is almost an inventory of the objects found in the paintings in the exhibition: mineral mountains, coral, fabulous trees, flowers, birds, animals, jewels. It is no wonder that Tibetans recognized in scholars' rocks an appropriate offering for an Arhat. Nor is it surprising that someone saw in the craggy piece of turquoise (cat. no. 26) a hybrid between a scholars' rock and a coral tree, setting it upright in a decorated stand for presentation on an offering table. This recognition of the opportunity to adapt precious objects for religious purposes is perhaps no more clearly illustrated than in the reuse of Chinese snuff bottles. In China and Tibet, snuff bottles were certainly not religious objects, but the ones made out of semiprecious stones, or their recent substitutes, were considered fit donations to monasteries. As snuff bottles were accumulated in significant numbers, monasteries often chose to inset them into the silver surface of reliquary *chortens* as in figures 20 and 21 from the Rongwo Gongchen in Amdo Rebgong, which was built to accommodate the relics of a departed incarnating lama.[77] Many examples can be found throughout Tibetan areas. It is instructive to see the reconfiguration of objects from China into Tibetan contexts. At the very heart of this exhibition is this broader refitting of local meanings onto imported forms.

6

TREASURE OFFERINGS CONTINUED: CHINESE FURNITURE IN ARHAT PAINTING

Chinese-style furniture is as evident in Tibetan paintings as are scholars' rocks, coral trees, and porcelain, and many examples, from incense stands to low tables to thrones and elaborate seats (figs. 22, 23), can be found in Tibetan paintings in the Rubin collections. Especially favored in the set of Arhat paint-

ings shown in the appendix and catalog no. 19 is the now-rare carved cinnabar-lacquer table. The tall incense stand of catalog no. 10 is a fine hardwood example of the type of table seen just behind the Arhat in catalog no. 15.

One of the more interesting types of Chinese furniture appearing in Tibetan Arhat paintings is the rusticated wooden chair. Some examples are clearly bamboo, as in the Chinese portrait of Lu Wending (cat. no. 8). Similar to the Tibetan examples, a colorful cloth is draped over the back of the chair, turning it into a seat of honor (compare catalog nos. 9, 15). In other cases, the Tibetan versions appear to be of wood but constructed like the Chinese examples, either lashed together or with carpentered joins.

The Chinese portrait of the scholar Lu Wending provides other points of comparison with Tibetan Arhat painting and shows how other "secular" genres of Chinese painting may have inspired Tibetan painters in their portraits of monks and Arhats. This Chinese image is one of ten portraits of Lu Wending originally painted on a continuous handscroll, showing him in different guises. His appearance as an elegant but relaxed scholar-in-reclusion must certainly have been influenced by Buddhist images of teachers and Arhats. Note the *chauri* (fly whisk) in his left hand, carried by one of the Arhat's attendants in catalog no. 19. The acolyte-servant in catalog no. 8 carries a wooden staff with a dragonlike finial, quite similar to the finial of the armrest painted on catalog no. 9 and the staff held by the Arhat himself in catalog no. 3. This is probably meant to represent *wansui teng,* a plant known as the "thousand-year liana" from which gnarled staffs for recluses, immortals, and Arhats are made.[78] Chairs, stools, and other furniture figure among the lists of gifts sent to various Tibetans in the early Ming and Qing dynasties, so it is not at all difficult to understand how they come to be in Tibetan Arhat paintings.[79]

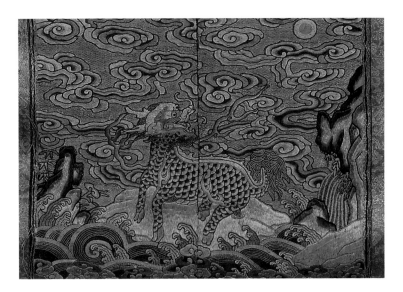

7

TEXTILES IN TIBETAN MONASTIC CULTURE AND ARHAT PAINTING

Figure 25. Qing rank badge, detail of fig. 24.

Chinese textiles were so integrated into Tibetan religious and aristocratic culture that it is hard to imagine the one without the other. Bold as this statement is, the history of Chinese textiles would be much the poorer without the treasures revealed within or now removed from Tibet.[80] By the same token, Tibetan material life would seem impoverished without the Chinese textiles used as mountings for *tangkas,* as temple banners, wall coverings, canopies, robes, throne seats and backs, Cham (ritual dance) costumes, and book wrappers, among other functions.[81] From the regions of cultural Tibet closest to China (that is, Amdo and Kham), to the most distant areas in the west (notably Ladakh and Zangskar), fine Chinese textiles have been prized and preserved in the monasteries and mansions.[82] No matter that the motifs employed in the textiles, and the functions for which they were originally designed, were as often as not basically secular, non-Buddhist. The fact that at best they had only vaguely religious associations

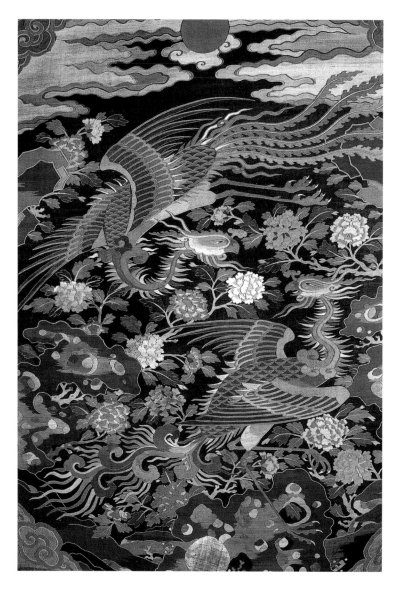

Figure 26. *Kesi* from Tashil-hunpo monastery, Shigatse (Tibet).

wore official rank badges at the Ming and Qing courts to convey their specific grades in the bureaucratic hierarchy. One of the rank badges now appears on the mounting of an appliqué *tangka* made in Tibet, forming the "door" on the lower skirt (figs. 24, 25).[83] This rank badge depicting a *qilin* (a Chinese mythical composite beast) was worn by a first-rank military official or an imperial noble of the ninth order.[84] It was originally part of a Qing robe as demonstrated by the slit down the center; each half being sewn to a different side of the robe, which was fastened in the middle of the chest. (By contrast, Ming-dynasty rank badges did not need to be cut, since at that time officials' robes were fastened on the side.) Embroidered imperial robes were also reused and recut in Ladakh. They were fashioned into small capes, which Ladakhi women wore on their backs, tied around their shoulders. On festival occasions, the colorful embroidered patterns of dragons rising from the sea replaced the goatskin capes Ladakhi village women still normally wear today.[85] Multihued rolls of Chinese silk, plain in color or with damasked patterns of flowers and stylized "auspicious" characters, were sewn into appliqué *tangkas* such as the one in figure 24.[86] The inventive reuse of Chinese textiles by Tibetans is as striking as the sheer quantity of Chinese silk that appears in Tibetan monasteries.

Bolts of Chinese silk were lavished on Tibetan teachers and aristocrats, whether or not they accepted invitations to visit China. For instance, in the early Ming, besides silk robes, one hundred and fifty bolts of silk were sent to Dragpa Gyaltsen (1374–1432), the prince (Desi) of Phagmo Drugpa, who never visited the court.[87] If he received so many, one can only imagine the quantities bestowed on those who, like the Fifth Karmapa and Shakya Yeshe, won the favor of the Chinese emperor by traveling to the court to perform rituals and initiations. An oral testimony later written down of an eye-

was beside the point. Woven or embroidered dragons may have conveyed imperium in China, but in Tibet they could be reinterpreted as majestic signs of the Buddha's teachings.

In the manner already discussed for snuff bottles, as textiles flowed into Tibet they were creatively reconfigured to fit Tibetan needs and values. For example, the Chinese

witness to the Sixth Panchen Lama's travels to the Qing court in 1780 mentions "one hundred pieces of curious silks" given at one stage of the journey, "one thousand pieces of brocade," and "two hundred pieces of yellow silks" at other stages. When the Sixth Panchen Lama arrived in the summer palace and hunting park in Jehol, where the Qianlong emperor had built a new "Tashilhunpo" for him, the emperor presented him with "many hundred pieces of curious silks" on one occasion, and "four thousand pieces of brocades" on another.[88]

The most highly prized of all Chinese textiles was the *kesi* (pron. kuh-suh).[89] The simplicity of a *kesi*'s construction belies the costly and time-consuming nature of its creation. The technique, slit-weave tapestry, produces a light but dense and durable fabric. *Kesi* rivaled painting in the subtleties of modulated color, without painting's vulnerability to moisture and creasing from repeated rolling or folding. *Kesi* banners were much more likely than paintings to survive the arduous trip to Tibet in perfect condition, and the generally cool, dry climate of Tibet was suited to their preservation. The *kesi* technique was brought to a high level of perfection in the Song dynasty. The Mongol rulers of the Yuan dynasty recognized its value and famously commissioned both imperial portraits and Tibetan-style mandalas in the *kesi* medium.[90] During the Yuan dynasty, it seems that Tibetans were themselves commissioning the main *kesi* workshops in Hangzhou to produce portraits and images of deities. Fortunately, several of these survive today.[91] In the Ming, a lifelike portrait of Shakya Yeshe, the disciple of Tsongkapa who visited the Ming court twice, was created in China. Inscribed in Chinese and Tibetan, this *kesi* was sent to Tibet, where it is still preserved.[92]

The Newark Museum's seventeenth-century *kesi* in the exhibition is a fine example of *kesi* designed in the Chinese style and

taste (cat. no. 21). Two phoenixes, one male and the other female, cavort in a garden among the now-familiar foraminate rocks, from which grow thick stems of peonies. The *kesi* has faded unevenly,[93] but some idea of its originally brilliant coloring is provided by comparing it to a similarly designed Ming *kesi* preserved in Tashilhunpo monastery (fig. 26).[94] The light blue background of the Newark *kesi* was probably originally much darker, its yellows and browns likely once a brilliant red.

The difference between the *kesi* preserved in China or Japan and those kept in Tibet can be quite dramatic. Morris Rossabi, the eminent historian of the Mongols and Inner Asia, points out that "Tibet proved an ideal place for the preservation of textiles, for in the monasteries they were stored in dark, dry rooms that offered protection from light and other potential sources of damage."[95] However, it was not always the case that such treasures were locked up in boxes. One still finds similar Chinese *kesi* panels pieced into composite pillar hangings in monasteries in both eastern and western Tibet (figs. 27, 28).[96] Other fine textiles with motifs like dragons and phoenixes, which are not overtly iconic, were stretched into canopies and displayed above altars or thrones in monastery halls.[97] There they became part of the visual culture of Tibet and were drawn on as a matter of course by Tibetan artists. At the same time, precious objects such as textiles and paintings depicting other precious objects such as wondrous garden rocks, exotic trees and flowers, and auspicious birds and animals helped to reinforce the impression made by the actual objects and creatures.

32

PARADISE AND PLUMAGE: CHINESE CONNECTIONS IN TIBETAN ARHAT PAINTING

Figure 27. Banner made of sewn pieces of Chinese textiles, including brocade, embroidery, and *kesi*, unidentified monastery in western Tibet (India), ca. 17th c.

8

of a means to penetrate into or beyond this screen of blue-and-green cliffs: a cave opens up, steps lead to a mysterious passageway, a waterfall suggests a spring in the background, or a stream meanders, its upstream course blocked by the sides of the cliff (cat. nos. 4, 6) In the minority with open compositions, there is a deep view around the foreground setting, and here the Tibetan painters' ability to control the means of representation is usually outstripped by the mastery of Chinese landscape artists. (Compare catalog nos. 13, 24.) Using both diminution of scale and the blurring of details to suggest distance, the optical phenomena of spatial atmospherics are beautifully rendered. The Tibetan versions of such compositions are, frankly, not as convincing as the Chinese, and generally, whether open or closed, the Tibetan compositions are flatter in terms of the illusion of volume, with rare exceptions. The Tibetan motifs seem more independent of one another, less unified by an experience of continuous space. In compensation, Tibetan artists strike out in different directions, less reliant on convincing illusions of traversable space.

9

BLUE-AND-GREEN LANDSCAPES IN ARHAT PAINTING, AN INTRODUCTION

As for the classic blue-and-green landscape (cat. nos. 4, 6, 20), there is something extraordinary about rocks painted with bright blues and greens. The appeal certainly transcends cultural boundaries. In part, it is the intensity of the colors that draws us in, for they are pure and unalloyed. But beyond this primary sensual pleasure, the viewer's experience is enhanced by the recognition of the artists' conceptual or representational witticism. The colors used to depict rocks are pure mineral pigments: both blue and green generally come from grinding up azurite and malachite (which can occur together,

LANDSCAPE COMPOSITIONS IN ARHAT PAINTING

Turning to the landscapes featured in Chinese and Tibetan Arhat paintings, there are two basic types of compositions. One is relatively enclosed, with no access to a far-off horizon, and the other is relatively open, with a view into deep distance. In both types, the foreground and middle ground are relatively shallow, with the Arhat and a tall tree that frames him from one side pushed toward the foreground. In the closed type, which is more common, the Arhat has found his seat at the base of tall cliffs that rise up steeply, creating an enclosed space cell surrounding the Arhat. (In the Southern Song Arhat painting [cat. no. 1], clouds close off the background, denying a view into the distance.) In many of the Chinese compositions, there is some hint

as in catalog no. 16) or, rarely, the bluer lapis lazuli. The wit is that by using these mineral pigments, including gold, the pure products of rocks are being used to represent rocks. In that sense, in looking at the blue-and-green landscapes, we are literally seeing mountains.

Blue-and-green rock painting was the most important artistic device appropriated by Tibetan artists from Chinese Arhat painting and from Chinese landscape painting in general. It is the artistic import with the single largest and longest-sustained impact on many kinds of Tibetan painting. In fact, it is still thriving in contemporary Tibetan painting. Whether as discrete motifs used as accents in smooth, plain settings (cat. no. 13) or as the unifying backdrop (cat. no. 25), blue-and-green painting became a staple of Tibetan art from the fifteenth century onward. In time, the Chinese contribution was internalized and so well integrated into Tibetan painting schools that the specific attribution to Chinese painting is largely forgotten. To Tibetan painters, blue-and-green landscapes are as much Tibetan as Chinese. As David and Janice Jackson point out:

> Many different techniques [for rocks and crags in landscapes] were practiced in the various schools of Tibetan painting, and some of the more sophisticated and realistic portrayals were no doubt adapted from Chinese examples. But whatever their ultimate stylistic origins, the painting of rocky crags as practiced by [contemporary painters] followed highly conventionalized and now typically Tibetan patterns.[98]

For the most part, what we see in the exhibition are the early stages of the Tibetan absorption of the Chinese patterns, a phase of enthrallment and clear debt, as the Tibetans were straightforwardly emulating Chinese paintings as closely as possible (cat. nos. 4–7). Before considering the distinctively Tibetan uses of blue-and-green rock painting, however, it is useful to know more about its early development in China.

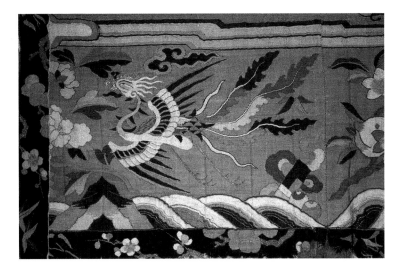

10

BLUE-AND-GREEN
LANDSCAPE PAINTING IN CHINA

Figure 28. Part of the *kesi*, detail of fig. 27.

In China, during the Song and Yuan periods, the blue-and-green style had two primary associations: elegant quaintness and nostalgic primitivism. Both were harnessed to the Arhat theme. Among the earliest antecedents of the blue-and-green style applied to Arhat figures is the figure of a generic meditating *bhikshu* (renunciant monk) or Arhat in Cave 285 at Dunhuang, datable to the mid-sixth century (fig. 29). Here the figure sits in a cave surmounted by tooth-shaped peaks laminated with alternate layers of bright blue and green. A more sophisticated version of the blue-and-green style can be found in Song copies of Sui- and Tang-dynasty court paintings, such as *Spring Outing,* attributed to the Sui-dynasty artist Zhan Ziqian, and *Minghuang's Journey into Shu,* by Li Zhaodao.[99] Nearly contemporary records describe the Tang-dynasty general and imperial-clan member Li Sixun (651–716) and his son Li Zhaodao (ca. 675–741) painting in the blue-and-green style. In many of the paintings thought to convey their style, the landscapes are shown as pleasure parks for the excursions and picnics of aristocrats. Although no

Figure 29. Meditating *bhikshu* or Arhat, detail of mural in cave 285, Dunhuang.

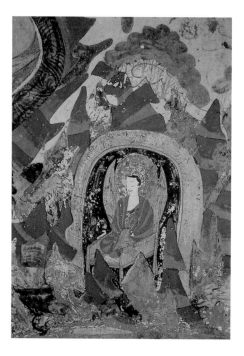

reliable paintings survive from their hands, innumerable paintings have optimistically been attributed to them.

In the classical narrative of Chinese art history, these landscapes were developed before powerfully observed naturalism was brought to its peak in the Northern Song period. Viewed from the perspective of painting achievements in the Song dynasty, the earlier Sui and Tang blue-and-green paintings began to be seen as quaint and naive, with an almost primitive quality, or a childlike simplicity and directness, as illustrated in figure 29. In later times, artists like Zhao Boju (d. ca. 1162) emulated this style to suggest purity, naturalness, and a fairyland atmosphere of antiquity. As the respected art historian Kiyohiko Munakata points out:

> The blue-and-green landscape style, which became a special means of expression for depicting scenes of the imaginary world or those from ancient stories, was standardized during the Southern Song to include gold as well as strong opaque colors.[100]

Under the great Northern Song aesthete, the emperor Huizong (1082–1135), already discussed as "a gifted artist and calligrapher, an avid collector of unusual rock specimens and ancient vessels, and a great lover of birds and animals,"[101] this "brilliant coloristic manner . . . was adopted by the Song imperial family as an appropriate emblem of their reign and was used widely throughout the Song period."[102] Like the members of the Li family, Zhao Boju has also been used as a convenient attribution for later paintings, sometimes of high quality, which take up this manner with a veneer of polish over the remote fantasy from the past. One example of a later painting claiming connection with Zhao Boju is a handscroll in the Metropolitan Museum of Art (fig. 30).

A second association, nostalgic primitivism, is the later, post-Song recourse to the Sui and Tang blue-and-green mode, as self-conscious naiveté. Artists such as Qian Xuan (ca. 1235–before 1307) and Zhao Mengfu (1254–1322) were famously embittered by, respectively, their political disenfranchisement by or reluctant engagement with the new Mongol rulers of the Yuan dynasty. In at least some of Qian's and Zhao's paintings, they consciously eschewed the sophisticated technical mastery of Song spatial naturalism and revived the older mode, creating a new primitivism that helped to express their nostalgia for bygone days.[103] Like ideal literati, they lodged their feelings in paintings that stylistically and thematically recalled Tang and even earlier dynasties, when the Chinese were similarly besieged by militarily powerful foreigners but ultimately demonstrated their creative cultural mettle. The blue-and-green style thus could be used for expressions of political allegiance, resentment, or even dissent.

The textbook example is Zhao's *Mind Landscape of Xie Youyu,* in which he paints a government official from the early fourth century in an elegant but still intentionally simplified blue-and-green landscape setting

(fig. 31). Although he collaborated with the Mongols in order to ameliorate the harshness of their rule of Han Chinese, Zhao Mengfu still felt the sting of criticism and guilt. In his predicament, he identified with Xie Youyu, who lived in a perilous time fraught with dangers at court. The latter's memory was preserved in literature as a recluse in his heart, best portrayed among hills and streams, even as he labored, much like Zhao, as an official in the capital. In Zhao's *Mind Landscape*,

> [He] sought to express his desire to retreat into seclusion by adopting a style from the past. The archaistic rock forms, the mountain formation, and the awkward spatial setting all detached the artist from the real world in which he was reluctantly involved and plunged him back into . . . the golden age of eremitism.[104]

In the early Ming, a prime period for the Chinese paintings in *Paradise and Plumage* (cat. nos. 4, 6, 24), the blue-and-green manner was no longer so fraught with notions of political resistence and nostalgia. After all, the Mongols had just been chased out of China, and the installation of a nativist, ethnically Han regime sustained hopes for a true renaissance of Chinese civilization. Aesthetically, as the Ming Arhat paintings with open compositions demonstrate (cat. no. 24), the Song techniques of convincing spatial illusionism could be combined in court painting with the blue-and-green style. Following a broader Ming trend toward the aestheticization of art, the delightful blue-and-green landscape of Beijing by the court academic painter Guo Chun (1370–1444) is richly evocative of Northern Song monumental landscapes of Li Cheng and Guo Xi (fig. 32). At the same time, its views into the misty distance recall Southern Song landscapes. Tiny narrative elements, such as the officials or aristocrats being rowed across the lake, echo the early Sui and Tang blue-and-green aristocratic outings.[105]

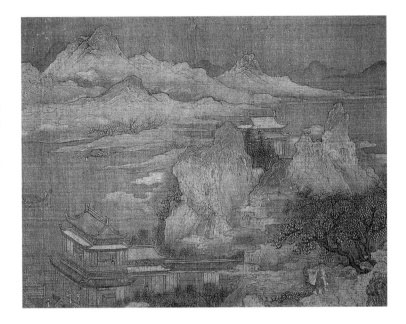

By the Ming, then, the primary valence of the blue-and-green landscape had become enduring purity, remoteness measured simultaneously in space and time, and a refinement hallowed by centuries of artistic practice. This is preserved into Qing-period painting, as in the early Qing portrait of Singde (figs. 9, 10). The otherwise muted composition is punctuated by a joyous burst of blue-and-green color in the foreground in the form of a garden rock. As already discussed, blue-and-green rocks served as an index of both refinement and reclusion, qualities with which the portrait's owner would want to be associated.

Figure 30. Unidentified Chinese artist, detail of *Spring Morning at the Palace of the Han Emperors*, handscroll, ink and pigments on silk, Ming or Qing dynasty. The Metropolitan Museum of Art, Collection of A. W. Bahr, Purchase, Fletcher Fund, 1947 (47.18.4).

11

PARADISE REVISITED:
BLUE-AND-GREEN LANDSCAPES
IN ARHAT PAINTING

In fifteenth-century Chinese painting, luminous blue-and-green rock formations, edged in gold, provided a congruent setting for venerable Arhats (cat. nos. 4, 6). Such landscape settings resonate with just the right qualities for the Arhat theme. This distinctive landscape mode

> was often used for depictions of Daoist paradises, visions of utopia, and idyllic scholarly retreats—places spiritually and physically apart from the ordinary world—and is thus also thematically appropriate for representations of the exotic residences of the Buddha's Indian disciples.[106]

The Tibetans recognized the appropriateness of blue-and-green landscape, which they acquired through imperial presentations and adopted for their own Arhat images, whether copies of the Ming versions (cat. nos. 5, 7, 13, 25) or compositions of their own devising (cat. nos. 3, 9, 15, 17, 19, 27).

The association between blue-and-green mountain settings and the Arhats must have been furthered by knowledge of Arhat lore and Buddhist texts. An early translation into Chinese locates the Arhats—all five hundred of them—in caves on the central mountain of Jambudvipa, the southern continent on which we live. "The so-called *Kw'un-lun* [i.e., Kunlun] mountain is the centre of Jambudvipa. The whole mountain consists of precious stones, and all around are 500 caves, all of yellow gold and always inhabited by 500 Arhats."[107] The affiliation between the Arhats and the caves and mountains was so strong that already in the twelfth century, sculptural sets of the Arhats "were placed in surroundings, imitating a cavernous mountain."[108]

12

TIBET AND CHINA:
SHARING AND INNOVATION,
INFLUENCE AND INSPIRATION

It is the thesis of this exhibition that, during visits to the courts of China, the Tibetan masters and their entourages were most likely exposed to the Ming palace gardens featuring garden and scholars' rocks and to high-quality examples of court painting such as catalog nos. 20, 22, 23. Given the documented exchange of luxury goods such as porcelains, textiles, furniture, and jades, alongside Buddhist imagery and paraphernalia in the fifteenth century and later, it would not have been unusual at all if court paintings and textiles such as the ones exhibited here (cat. nos. 20–23) were included among the gifts intended for Tibetans. The many Chinese textiles, ceramics, furniture, and other precious objects conserved in Tibetan monasteries bear this out (figs. 18–21, 24–28). Tibetan monks who experienced the palaces and grounds of the Ming capitals would have preserved and conveyed their memories as well as the objects derived from their travels. Both memories and objects would then have stimulated the admiration and imaginations of artists in Tibet. We know from the evidence of Tibetan paintings and the objects that have been safeguarded down to today in Tibetan monasteries that Tibetan monks and artists were naturally attracted to the beauty and exotica in Chinese art. Tibetan artists, like their Chinese Buddhist counterparts, would have recognized the suitability of blue-and-green landscapes and luxury goods for outfitting Arhat paintings. As a result, they began to regularly incorporate these Chinese-prototype motifs and settings into many of their compositions, Arhat paintings included.[109]

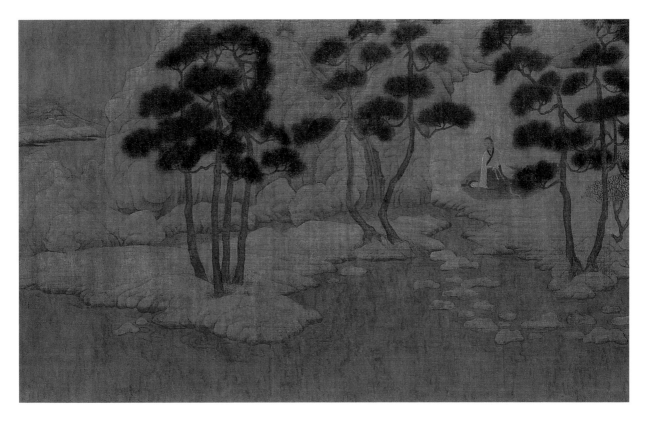

Although many of the Tibetan Arhat paintings owe one or another debt to Chinese art, it is clear that the Tibetan artists treated the Chinese blue-and-green and ink landscapes in different ways, taking them in distinctive directions. The difference between Tibetan and Chinese treatments of similar themes is apparent in catalog no. 17, a Tibetan work. The background around the staggered rock form is left mostly unpainted, a convention quite common in Chinese painting (cat. nos. 2, 8, 22, 23; figs. 29–31). Both the dragon bearing the tray with the vase and the lacquered basket with a pair of fish are equally familiar in popular Chinese imagery of auspicious events. What is ultimately Tibetan about the painting is the unabashed centrality of the Arhat in the composition and the dissociation between the figure and the setting.

The precisely arranged overlapping of the tails of the fish with the rug that hangs over the front of the low throne creates a formality that resists relaxed naturalism. Chinese painters integrate each object into a whole through more interlocking compositions and through softened outlines, which blur boundaries between one object and another, suggesting a shared atmosphere (cat. nos. 22, 23; fig. 9). The Tibetans give each object its due in an overall hierarchy of importance but do not feel obliged to stitch them together other than in a formal placement.

One painting in particular exemplifies the distinctively Tibetan uses made of the blue-and-green style (cat. no. 27). It is almost as if a Tibetan artist has exposed the Chinese blue-and-green rocks to radioactive light, and the colors have been transformed

Figure 31. Zhao Mengfu (Chao Meng-fu, 1254–1322) *The Mind Landscape of Xie Youyu* (*Hsieh Yu-yu;* Yu-yu Ch'iu-ho). Handscroll, ink and colors on silk. Princeton University Art Museum. Edward L. Elliott Family Collection. Museum Purchase, Fowler McCormick, Class of 1921 Fund.

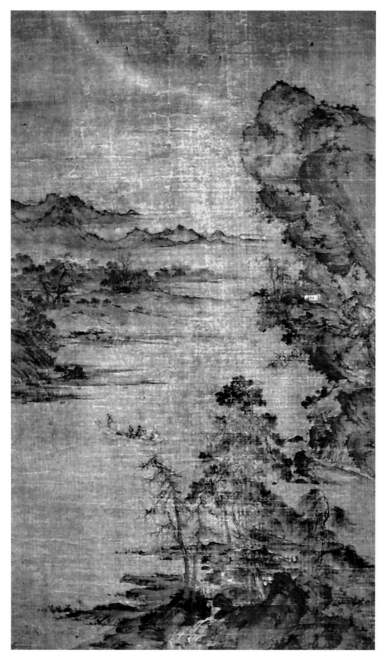

Figure 32. Guo Chun (1370–1444), landscape painting, hanging scroll, ink and pigments on silk, 15th c.

into yellow-red-blue-and-green. The original Chinese practice of adding ink or gold linear contours and alternating colors so as to model the rocks has also been radically altered. The Tibetan artists give each faceted surface a limited independence from the collective purpose. Each rock-unit seems freed of a cliff-root common to the other units and, tilted on its axis, seems cemented into a cavelike niche. Other elements are notably Chinese in origin: the entwined broad-leafed trees on the left with their exposed gnarled roots, the palatial architecture with upturned eaves and balustrades surrounding Vaishravana in the lower right, the intricately patterned inner and outer robes worn by the two Arhats, the method of tying the outer robe with a ring below the shoulder on the left Arhat, and the idealizing portraits of the faces. The shoulder ring convention is a distinctively Chinese (or, more properly, East Asian, as it is followed in Japan and Korea as well) characteristic of monastic garb that the art historian Amy Heller has recently argued would already have been understood in Tibet by the eleventh century as referring to Chinese Buddhism.[110] Despite the extensive sharing or overlap with Chinese motifs, the bricolage of elements from China, this painting would never be mistaken for Chinese. On the one hand, the color scheme aligns it with the Tibetan red-ground *(tsal-tang)* type of painting. On the other hand, the bold, almost egregious denial of the binds of spatial coherence and continuity of scale—as in the waterfalls that must be understood as rivulets when they flow past the Arhats, or in the palace overlapping the lower Arhat's attendant—is much more common in Tibetan painting.[111] By tampering with the shared inheritance of Tibetan and Chinese art, this painting is emblematic of the independent-mindedness of Tibetan artists, even as they participated in a shared horizon.

13

CONCLUSION: CHINESE CONNECTIONS IN TIBETAN ARHAT PAINTING

The basic Buddhist significance of the Arhat, a fully enlightened sage entrusted with the historical Buddha's teachings, was largely equivalent in both China and Tibet. Of course, each culture had its own distinctive overtones. For example, when the Arhat theme came to China from India, the independent, miracle-working, death-defying saint of Buddhism lined up neatly with the ancient Chinese category of the *xian,* or immortal.[112] In time, this immortal may have been stimulated by the Arhat figure and overlaid with the more worldly recluse-litereratures known as the Seven Sages of the Bamboo Grove; perhaps in turn this figure then developed into the immortal of religious Daoism.[113] In the artistic sphere, there is definitely an overlap between the eccentric Arhats and the Daoist immortals with protruding foreheads and bushy eyebrows. Even the remote mountain backdrops are common to both, as are the shallow outdoor settings framed by a magnificent tree and an occasional glimpse of distant hills. The cranes, deer, dragons, and phoenix are as apt to figure in the landscape of a Daoist immortal as a Chinese Arhat.[114] Although these motifs play important roles in Tibetan paintings of Arhats as well, for Tibetans the Arhats resonate less with Daoism and ancient cults of the immortals than with India and the mythical mountain retreats to which they are systematically assigned.

The iconographic meaning of the Arhat shared by Tibet and China certainly outweighs the separate cultural associations. This commonality of meaning helps us to understand how a recognizable pictorial language applied to the Arhat theme could circulate within both Chinese and Tibetan cultural regions. It also helps explain how it was that at irregular intervals, Chinese image-making traditions inspired Tibetan artists, and Tibetan modes of depiction in turn entered China and modified artistic practice at least at court. Graphic examples of Tibetan artists following Chinese models are featured in this exhibition. In fact, one could hardly imagine a better opportunity to examine the similarities and differences among and between Chinese and Tibetan executions of identical compositions. Three pairs of paintings—catalog nos. 4 and 5, 6 and 7, and 24 and 25—feature a Chinese and a Tibetan version of the same Arhat in related settings. It is abundantly clear that in catalog nos. 5 and 7, Tibetan artists working later than the Chinese "originals" had models of the Chinese paintings available to them. The intertwining of the tree trunks, the curving of the branches, the precise angle of the removed shoes, all indicate dependence on a Chinese composition. Of course, there is very little known about the inspiration for the Chinese "originals." Likely, they were based on earlier works, which may have been, at least in part, inspired by Tibetan paintings. In fact, the anecdote with which this essay began shows that early in the Yongle period, a set of Tibetan Arhat paintings was presented to the Chinese court by the Fifth Karmapa.

Even as we are attentive to the dependence of Tibetan artists on Chinese art for the compositions, at the same time, it is very instructive to notice what the Tibetans add, subtract and transform. In all three of the Tibetan members of the pairs (cat. nos. 5, 7, 25), but not the Chinese mates, a seated Buddha image with head nimbus, body nimbus, and round light-emitting aureole floats above the figures of Arhats and attendants. In examples not included in the exhibition, other deities in the Tibetan Buddhist pantheon are also portrayed above the figures of Arhats and attendants (fig. 7). This iconographic feature is rather distinctive to Tibetan sets of Arhat paintings and seems

to have originated in Tibet. In some later Chinese versions of Arhat painting, however, we find that this aspect has migrated from Tibet to China. In the eighteenth century, the ethnically Han-Chinese court artist Yao Wenhan created a set of Arhat paintings for the Qianlong emperor. As Patricia Berger and others have pointed out, they were explicitly modeled after Tibetan Arhat images as arranged by the Qianlong emperor's great friend and Tibetan religious mentor Rolpai Dorje (1717–1786), the Third Zhangjia National Preceptor.[115] Not only are the affiliated deities added to the compositions, but the set of sixteen is now supplemented with the Arhat lay-attendants Dharmatala and Hvashang in accordance with the Tibetan tradition. Even the most hallowed set of Chinese Arhat painting traditions, those attributed to the painter Guanxiu, was copied at the Qianlong emperor's order by the Chinese court artist Ding Guanpeng. Once again, under the supervision of Rolpai Dorje, the set was renamed and reordered according to the Tibetan understanding of the Arhats, and Tibetan inscriptions were added to the Chinese artist's paintings.[116] In turn, versions of these Tibetan-arranged, Chinese-inspired images made their way from the Qing-dynasty capital to Tibet and continued to inspire Tibetan Arhat paintings. Figure 7, for example, although undeniably indebted to Guanxiu's paintings, is more closely related to the Qing versions.[117]

The point here, and ultimately the point of this exhibition, is that the Chinese and Tibetan artists have enriched and cross-fertilized each others' artistic production for the last five hundred years or more. Although it is, perhaps, easier to identify the Chinese "influence" on Tibetan art, it is more helpful to think of this phenomenon as the circulation of forms and meanings within a shared or overlapping cultural horizon, rather than the enthrallment or debt of one culture to another. And in the end, although one can identify motifs and treatments in Tibetan paintings of the Arhats (and other themes) as originating in China proper—which this exhibition aims at illustrating—on the whole, with certain exceptions, it is not hard to recognize distinctively Tibetan imaginations at work. Chinese idioms of blue-and-green landscape, spatial relations, figural stereotypes, and garment patterning are extremely well internalized by the Tibetan artists of the Rubin/Kumar set (cat. nos. 3, 15, 19; and see appendix). But edgy contrasts of color—the deep blue skies, pink, yellows, and flaming red clouds—and flattened, unstitched spatial seams all express the Tibetan origin of this set. These subjective features are supplemented by the Tibetan inscriptions, indicating a Tibetan patron, and color notations on the underdrawing in Tibetan script (visible where the pigment has flaked off), offering strong evidence of Tibetan artists at work.[118]

In the utopian image of the blue-and-green landscape painting, Tibetan artists saw great possibilities for the expression of their own values. And in the splendid display of colorful plumage found in and on Chinese luxury objects as diverse as paintings, ceramics, and textiles, Tibetans recognized a means to insert into their religious painting both the pleasure of the exotic and an expression of their esteem for the deities. Certainly, an Arhat or a Lama appreciates and deserves the finest treasures, just as the mandala-offering stipulates offering materials such as coral and turquoise. It was easy enough to include the finest blue-and-white porcelain, the best furniture and textiles into the category of "treasure offerings." The realities of an enduring, complex relationship between Tibet and China, of tribute, trade, rivalry, and patronage, ultimately provided subjects for the imagination, and it is from the sphere of artistic creativity that these cultural objects emerge, loaded with history, but still fresh enough to engage us today. ✦

Notes

1 Heather Karmay, *Early Sino-Tibetan Art* (Warminster: Aris and Phillips, 1975), p. 78.

2 Dungkar Rinpoche et al., *Sera Thekchen Ling* (Beijing: Nationalities Press, 1995), pp. xvi, 161.

3 For accounts of the visits of the Shakya Yeshe and Kunga Tashi, see Elliot Sperling, "Early Ming Policy toward Tibet: An Examination of the Proposition That the Early Ming Emperors Adopted a 'Divide and Rule' Policy toward Tibet," Ph. D. diss., Indiana University, 1983, pp. 138–56.

4 Josef Kolmas, *Tibet and Imperial China: A Survey of Sino-Tibetan Relations up to the End of the Manchu Dynasty in 1912* (Canberra: Centre of Oriental Studies, Australian National University, 1967), pp. 35–36; Glenn H. Mullin, *The Fourteen Dalai Lamas: A Sacred Legacy of Reincarnation* (Santa Fe: Clear Light, 2001), pp. 203–5. The visit of the Sixth Panchen Lama is discussed in Schuyler Cammann, "The Panchen Lama's Visit to China in 1780: An Episode in Anglo-Tibetan Relations," *The Far Eastern Quarterly* 9, no. 1 (1949): 3–19; Patricia Berger, *Empire of Emptiness: Buddhist Art and Political Authority in Qing China* (Honolulu: University of Hawai'i Press, 2003), pp. 167–97; Captain Samuel Turner, *An Account of an Embassy to the Court of the Teshoo Lama in Tibet* (1800; reprint, New Delhi: Manjusri Publishing House, 1971), esp. pp. 443–48, 457–73. For a version of these events from a Chinese point of view, see Meng Zi et al., *The Hidden Tradition: Life Inside the Great Tibetan Monastery Tashilhunpo* (Beijing: Foreign Languages Press, 1993), pp. 128–31.

5 Zla-be-tshe-ring, Jiang Cheng'an et al., *Precious Deposits: Historical Relics of Tibet, China,* 5 vols. (Beijing: Morning Glory Publishers, 2000). Hereafter abbreviated as *Precious Deposits,* followed by volume number.

6 Sperling, "Early Ming Policy," p. 204.

7 For Tibeto-Chinese Ming sculpture preserved in monasteries in Tibet, see Ulrich von Schroeder, *Buddhist Sculptures in Tibet,* vol. 2, *Tibet & China* (Hong Kong: Visual Dharma Publications, 2001), pp. 1237–91; also Karmay, *Early Sino-Tibetan Art,* pp. 72–103. For the Qianlong emperor's infusion of Tibetan traditions of Arhat painting into China, see Berger, *Empire of Emptiness,* pp. 127–48.

8 Arhats are known as *Lohan* in Chinese, *Neten* (gNas-brtan) in Tibetan, and *Sthavira* in Sanskrit. The word *Arhat* means "worthy," "elder," or "deserving veneration." See M. W. de Visser, "The Arhats in China and Japan," *Ostasiatische Zeitschrift* 8 (1918/19): 88; Reginald A. Ray, *Buddhist Saints in India* (New York: Oxford University Press, 1994), pp. 204–5.

9 As de Visser points out, "the title of Arhat, in the fullest sense of the word, belongs only to him who has reached complete knowledge" (de Visser, "Arhats in China and Japan," [1918/19], p. 93).

10 Loden Sherap Dagyab, *Tibetan Religious Art* (Wiesbaden: Otto Harrassowitz, 1977), p. 60.

11 Much of the discussion of the meaning of the Arhats in Tibetan practice derives from conversations with Gene Smith and Jeff Watt, to whom I owe many thanks. They are not responsible for any errors that remain.

12 For a view of the Tsogchen assembly hall with a set of Arhat images hung on the inner well, see Phuntsok Namgyal et al., *Tibetan Buddhist Monastery Bkra-shis-lhum-po* (Beijing: Encyclopedia of China Publishing House, 1998), pp. 61, 65.

13 Several anecdotes of Atisha concerning Arhats are given in Dagyab, *Tibetan Religious Art,* pp. 62–63.

14 This sutra is discussed and summarized in Ray, *Buddhist Saints,* pp. 179–85; see also Richard K. Kent, "Depictions of the Guardians of the Law: Lohan Painting in China," in *Latter Days of the Law: Images of Chinese Buddhism 850–1850,* ed. Marsha Weidner (Lawrence: Spencer Museum of Art, University of Kansas, 1994), p. 186. Large sections of the sutra are translated and summarized in de Visser, "Arhats in China and Japan," (1922/23): 60–64. The Taisho number is 2030. See also Lewis Lancaster, *The Korean Buddhist Canon: A Descriptive Catalogue* (Berkeley: University of California Press, 1979), no. K1046; Bunyiu Nanjio, with additions by Lokesh Chandra, *A Catalogue of the Buddhist Tripitaka* (Delhi: Jayyed Press, 1980), no 1466. This text is placed in the Kanjur in the Stok catalog, but in other Tripitaka, into the Tenjur; see Tadeusz Skorupski, *A Catalogue of the Stog Palace Kanjur* (Tokyo: The International Institute for Buddhist Studies, 1985), Stok no. 319; Ui Hakuju et al., *A Complete Catalogue of the Tibetan Buddhist Canons (Bkah-hgyur and Bstan-hgyur)* (Sendai, Japan: Tohoku Imperial University, 1934), no. 4146.

15 Tohoku Daigaku Indogaku Kenkyukai, *A Catalogue of the Tohoku University Collection of Tibetan Works on Buddhism,* ed. Yensho Kanakura (Sendai: Seminary of Indology, Tohoku University, 1953), nos. 5561, 5645, 6320, 6332. Hereafter, abbreviated as "Toh."

16 Toh. 6016–6022.

17 Dagyab, *Tibetan Religious Art,* p. 60.

18 Giuseppe Tucci, *Tibetan Painted Scrolls* (Rome: La Libreria Della Stato, 1949), p. 562.

19 Ibid., p. 558. Dharmatala is also known as Dharmatrata.

20 Ibid., pp. 561–62, 568.

21 Stephen Little, "The Arhats in China and Tibet," *Artibus Asiae* 52, nos. 3/4 (1992): 255–81. He states that Hvashang was not incorporated into the Arhats before 1335 and believes the painting he discusses includes "one of the earliest surviving images of Hva Shang in Tibetan painting." Little's discussion of the origins of both the Hvashang and Dharmatala images is particularly insightful.

22 John Lowry, "A Fifteenth Century Sketchbook (Preliminary Study)," in *Essais sur l'Art du Tibet,* ed. Ariane Macdonald and Yoshiro Imaeda (Paris: Librarie d'Amerique et d'Orient, 1977), pp. 83–102. Reservations about the dating of some of the drawings in the sketchbook are raised and the close connection to Tibetan patronage is underscored in A. W. Macdonald and Anne Vergati Stahl, *Newar Art: Nepalese Art during the Malla Period* (Warminster: Aris and Phillips, 1979), p. 143.

23 See Jacques Giès and Monique Cohen, *Sérinde, Terre de Bouddha: Dix siècles d'art sur la Route de la Soie* (Paris: Réunion des Musées Nationaux, 1995), pp. 66–68.

24 For more on this site, see Rob Linrothe and Melissa Kerin, "Discovery Through Deconstruction: The Art of the Karsha Kadampa Chorten Revealed," *Orientations* 32, no. 10 (2001): 52–63.

25 Both Tucci and Kent discuss this dual appearance: see Tucci, *Tibetan Painted Scrolls,* p. 563; Kent, "Depictions," pp. 188–91.

26 Janet Baker, "Foreigners in Early Chinese Buddhist Art: Disciples, Lohans, and Barbarian Rulers," in *The Flowering of a Foreign Faith: New Studies in Chinese Buddhist Art,* ed. Janet Baker (Mumbai: Marg Publications, 1998), p. 85.

27 See, e.g., the partial set published in Gisèle Croës, *Splendor of Yongle Painting: Portraits of Nine Luohan* (Brussels, 2002), two of which are in the present exhibition and catalog (cat. nos. 4 and 6). Most are sinicized, but one is in the foreign, grotesque mode (Croës, *Splendor,* no. 8), and another has a mildly exaggerated bumpy head (Croës, *Splendor,* no. 1). In the later, but related set in the Yonghegong, of the eighteenth century, the ethnic stereotyping is less overt for the Arhats but continues in the caricature mode for the attendants. See Niu Song et al., *Yonghegong tangke guibao,* vol. 1 (Beijing: Beijing Publishing House, 2002), 59–76. The same is true for a painting in the Robert and Lois Baylis collection; it and another Arhat painting in their collections may be Chinese. See www.himalayanart.org, HAW nos. 90303, 90323. If not, they may be early Tibetan versions of the

Yongle set, like one in the Navin Kumar collection, which Marylin Rhie has dated to the second quarter of the fifteenth century; Marylin Rhie, "Tibetan Painting: Styles, Sources, and Schools," in *Worlds of Transformation: Tibetan Art of Wisdom and Compassion* by Marylin M. Rhie and Robert A. F. Thurman (New York: Tibet House, 1999), p. 57. The partial set in the Brooklyn Museum of Art consisting of nine Tibetan paintings, although very close to the Chinese compositions and types, is more neutral for both Arhats and attendants. See www.himlayanart.org, HAW nos. 86914–22.

28 See Himalayan Art Website thematic set 527, www.himalayanart.org, index "Arhats (block-prints)." Also included in Dege yinjing yuan huihuizu, *Dege yinjingyuan zangchuan muke zhang hui ji* (Chengdu: Sichuan Minzu Publishing, 2002), pp. 26–41. The question of the differences in attitudes toward physical markers of ethnicity, xenophobia, and stereotyping as registered in religious art is a subject much in need of serious work. A prolegomenon was offered in Rob Linrothe, "Patriarchs and Patrons: Images of Ethnicity in Tibetan Religious Painting," New York Conference on Asian Studies, 2002 Annual Meeting, 26 October 2002, unpublished paper.

29 Roderick Whitfield and Anne Farrer, *Caves of the Thousand Buddhas: Chinese Art from the Silk Route* (New York: George Braziller, 1990), no. 54.

30 Kent, "Depictions," p. 189.

31 Berger, *Empire of Emptiness*, pp. 127–41.

32 Amy McNair, catalog entry in *Latter Days of the Law*, pp. 262–64.

33 See Watanabe, "Guanxiu," pp. 34–42. See also the summary of Arhat painting in China in Thomas Lawton, *Chinese Figure Painting* (Washington, D.C.: Freer Gallery of Art, 1973), p. 117. For the set of one hundred paintings of five hundred Arhats dated 1178, see Wen Fong, *The Lohans and a Bridge to Heaven* (Washington, D.C.: Freer Gallery of Art, 1958).

34 One example of a contemporary mix that gives prominence to the Guanxiu type is Fung Huen-tai, *The Illustrated 500 Lo Han* (Hong Kong: Precious Art Publications, 1986).

35 See James M. Hargett, "The Pleasure Parks of Kaifeng and Lin'an during the Sung (960–1279)," *Chinese Culture* 30, no. 1 (1989): 61–78, esp. pp. 64–66, for the background history of imperial parks; p. 70 for the contingent of exotic animals and birds cared for.

36 Peter C. Sturman, "Cranes above Kaifeng: The Auspicious Image at the Court of Huizong," *Art Orientalis* 20 (1990): 36. This source

also provides a list of the auspicious animals in the imperial gardens of the Song.

37 Hargett writes that in the Song, "Imperial parks were regularly opened to the public, especially during spring festivals" ("Pleasure Parks," p. 69).

38 Rolf A. Stein, *The World in Miniature: Container Gardens and Dwellings in Far Eastern Religious Thought* (Stanford: Stanford University Press, 1990), p. 96; see also Wu Boli's late fourteenth-century painting *Dragon Pine* and Wen Zhengming's painting of junipers dated 1532, Stephen Little and Shawn Eichman, *Taoism and the Arts of China* (Chicago: Art Institute of Chicago, 2000), nos. 141, 147.

39 For a "dragon rock" *ruiying* in the imperial garden, recognized, named, and painted by the Song Emperor Huizong, see Sturman, "Cranes," pp. 34–36. Also see Patricia Ebrey, "Taoism and Art at the Court of Song Huizong," in Little and Eichman, *Taoism*, pp. 99–103.

40 Robert Mowry, *Worlds within Worlds: The Richard Rosenblum Collection of Chinese Scholars' Rocks*, ed. Robert D. Mowry (Cambridge: Harvard University Art Museums, 1997), p. 21. On the practical aspects of assembling a garden with exotic rocks and plants from all over China and the "Flower and Rock Network" that was employed to procure them, as well as descriptions of the variety of exotic rocks, see James M. Hargett, "Huizong's Magic Marchmount: The Genyue Pleasure Park of Kaifeng," *Monumenta Serica* 38 (1989–90): 1–48.

41 This literature is reviewed in Craig Clunas, *Fruitful Sites: Garden Culture in Ming Dynasty China* (Durham: Duke University Press, 1996).

42 Quoted in Stein, *World in Miniature*, p. 39.

43 Stein, *World in Miniature*, p. 29.

44 In later depictions, Huike is shown holding his forearm, which he has just amputated in order to convince Bodhidharma that he is absolutely sincere in his desire for the teachings.

45 Su Siyi et al., *Stone Carvings at Shaolin Temple* (Beijing: Wenwu Chubanshe, 1985), no. 21. The calligraphy on the main part of the stele is by the famous Northern Song calligrapher Huang Tingjian (1045–1105). For other Bodhidharma stele at Shaolin, see Susan H. Bush and Victor H. Mair, "Some Buddhist Portraits and Images of the Lü and Ch'an Sects in Twelfth- and Thirteenth-Century China," *Archives of Asian Art* (1977–78): 32–51.

46 Clunas, *Fruitful Sites*, pp. 73–74.

47 John Hay, "Structure and Aesthetic Criteria in Chinese Rocks and Art," *Res* 13 (1987): 19. Hay describes this type as "the holy of holies in the shrine of petrophilia" (p. 5).

48 Clunas, *Fruitful Sites*, pp. 75–76.

49 For a summary of Singde's life, as well as that of the painter, Yu Zhiding (1649–1702), see Arthur W. Hummel, *Eminent Chinese of the Ch'ing Period (1644–1912)* (Washington, D.C.: Library of Congress, 1944), pp. 662–63, 941.

50 Perhaps a useful analogy for tray rocks in contemporary American experience is the four-wheel-drive SUVs and hiking boots owned by young suburbanites as if to suggest an outdoor lifestyle that in fact they rarely have the opportunity to enjoy.

51 Clunas, *Fruitful Sites*, passim; Stein, *World in Miniature*, pp. 37–39.

52 Clunas, *Fruitful Sites*, p. 172.

53 Stein, *World in Miniature*, pp. 37–39.

54 On the Tibetan knowledge, sources, and use of azurite and the closely related malachite, see David Jackson and Janice Jackson, *Tibetan Thangka Painting: Methods and Materials* (Ithaca: Snow Lion Publications, 1984), pp. 75, 78–79; also idem, "Lama Yeshe Jamyang of Nyurla, Ladakh: The Last Painter of the 'Bri gung Tradition," *The Tibet Journal* 27, nos. 1–2 (2002): 160–61.

55 See Claudia Brown, "Chinese Scholars' Rocks and the Land of Immortals: Some Insights from Painting," in Mowry, *Worlds within Worlds*, pp. 57–75. See also Clunas, *Fruitful Sites*, pp. 98–100.

56 Franco Ricca and Erberto Lo Bue, *The Great Stupa of Gyantse* (London: Serindia, 1993); and Wang Jui and He Dan, *The Kumbum of Gyantse Palcho Monastery in Tibet* (Chendu: Tibet People's Publishing House and Sichuan Nationalities Publishing House, 2001); for the version of blue-and-green caves and mountains, see pls. 70–73 and 225.

57 John Lowry, "Fifteenth Century Sketchbook," p. 115, fig. A38.

58 Other Rubin collections Arhat paintings with scholars' rocks in incense burners can be found on the Himalayan Art Website: www.himalayanart.org, HAW nos. 10, 163, and 541.

59 It is possible the irregularly shaped rocks are actually small pieces of barklike incense arranged to suggest a miniature mountain. The Arhat of catalog no. 15 appears to be adding a piece of rock or incense to the cluster already arranged in his censer.

60 Hay, "Structure and Aesthetic Criteria," p. 12. This also recalls the "universal mountain censers" *(boshanlu)* excavated from Han-dynasty tombs. See Little and Eichman, *Taoism*, no. 20.

61 Xinru Liu, *Ancient India and Ancient China: Trade and Religious Exchanges, AD 1–600* (Oxford: Oxford University Press, 1988), pp. 54–57.

62 Ibid., pp. 92–102. For the sources from which the Chinese historically derived coral, lapis lazuli, pearls, and other precious objects, see Chen Hsia-Sheng, "Materials Used in Ch'ing Dynasty Jewelled Costume Accessories," in *Catalogue of the Exhibition of Ch'ing Dynasty Costume Accessories,* trans. Rob Linrothe (Taipei: National Palace Museum, 1986).

63 See the transparent glass vase with a coral tree in a painting in the Rubin personal collection at www.himalayanart.org, HAW no. 362.

64 Management Committee of Cultural Relics of the Tibetan Autonomous Region, *A Well-Selected Collection of Tibetan Cultural Relics* (Beijing: Forbidden City Publishing House, 1992), no. 54.

65 Karmay, *Early Sino-Tibetan Art,* pp. 80–81.

66 *Precious Deposits,* vol. 4, no. 18, pp. 42–43. Other examples of Ming and Qing ceramics preserved in Tashilhunpo monastery are found in Namgyal et al., *Tibetan Buddhist Monastery,* pp. 172, 174.

67 The tripod censer is without the carving for which the wares of Yaozhou kilns are famous. On Yaozhou, see Margaret Medley, *The Chinese Potter: A Practical History of Chinese Ceramics* (Ithaca: Cornell University Press, 1976), pp. 115–18; Mary Tregear, *Song Ceramics* (New York: Rizzoli, 1982), pp. 101–8; S. J. Vainker, *Chinese Pottery and Porcelain: From Prehistory to the Present* (New York: Braziller, 1991), pp. 112–15.

68 *Precious Deposits,* vol. 4, pl. 198. Although its present location is not disclosed, the caption states: "This porcelain cup was fired at the Ge Kiln in the Song Dynasty. At that time, many Song porcelain wares were brought into Tibet. . . ." For another bowl, see Tibetan Administrative Office of the Potala, *The Potala: Holy Palace in the Snow Land* (Beijing: China Travel and Tourism Press, 1996), p. 1878.

69 For a seventeenth-century woodblock illustration of a Chinese Buddhist temple in which similarly shaped vases and tripod incense burners are depicted on an altar, see Rose Kerr et al., *Chinese Art and Design* (London: Victoria and Albert Museum, 1991), p. 104. The form is also very close to that of a pair of Qing-dynasty Qianlong-period cast-bronze vessels, part of a set of altar furnishings in the Phoenix Art Museum. Jan Stuart and Evelyn S. Rawski, *Worshiping the Ancestors: Chinese Commemorative Portraits* (Washington, D.C.: Freer Gallery of Art and Arthur M. Sackler Gallery, 2001), p. 47, fig. 1.6.

70 John Carswell, *Blue and White: Chinese Porcelain and Its Impact on the Western World* (Chicago: The David and Alfred Smart Gallery, 1985).

71 *Precious Deposits,* vol. 3, pls. 116–17. Chen Xiejun et al., *Treasures from Snow Mountain: Gems of Tibetan Cultural Relics* (Shanghai: Shanghai Museum, 2001), nos. 96, 97 (with Tibetan inscriptions); for other examples of blue-and-white preserved in Tibet, see nos. 86, 87, 89, 94, 95.

72 *Precious Deposits,* vol. 5, pls. 8, 89–90. Related techniques, such as Qing enamel wares and cloisonné, are also attested; see ibid., vol. 4, pls. 71, 91.

73 For observations of contemporary Tibetan artistic practice in eastern Tibet, see Rob Linrothe, "Creativity, Freedom and Control in the Contemporary Renaissance of Reb gong Painting," *Tibet Journal* 26, no. 3–4 (2001): 5–90.

74 Parmandanda Sharma, *Santideva's Bodhicharyavatara* (New Delhi: Aditya Prakashan, 1990), pp. 32–44. Jeff Watt kindly provided me with this reference.

75 Patrul Rinpoche, *Kunzang Lama'i Shelung: The Words of My Perfect Master,* trans. Padmakara Translation Group (New Delhi: Vistaar Publications, 1998), p. 285.

76 Dilgo Khyentse, *The Wish-Fulfilling Jewel: The Practice of Guru Yoga According to the Longchen Nyingthig Tradition,* trans. Könchog Tenzin (Delhi: Shechen and Shambhala, 1988), pp. 39–40.

77 After describing the traditional offerings (n. 73), Shantideva implies that such offerings are also due to stupa-reliquaries (Sharma, *Santideva's Bodhicharyavatara,* p. 45).

78 Stein, *World in Miniature,* p. 101.

79 For example, the Fifth Karmapa, upon arrival in Nanjing, 1406, was given such gifts as silks, stuffed cushions, and a saddled horse, and the following year, given silk pennants, portable stoves, lanterns, furniture (including chairs and stools), and basins. Karmay, *Early Sino-Tibetan Art,* p. 76.

80 See James C. Y. Watt and Anne E. Wardwell, *When Silk Was Gold: Central Asian and Chinese Textiles* (New York: The Metropolitan Museum of Art, 1997); Hong Kong Museum of Art, *Heaven's Embroidered Cloths: One-thousand years of Chinese Textiles* (Hong Kong: The Council, 1995); the many articles by Valrae Reynolds related to textiles in Tibet; and Michael Henss, "The Woven Image: Tibeto-Chinese Textile: Thangkas of the Yuan and Early Ming Dynasties," *Orientations* 28, no. 10 (1997): 26–39.

81 An excellent illustration of this point is a photograph of the Eastern Audience Hall in the Potala in Lhasa, where all manner of Chinese textiles are used for many of the functions just listed. See Administrative Office of the Potala, *Potala: Holy Palace,* p. 40.

82 In the early monuments of western Tibet (Spiti, Ladakh, and Zangskar), Indian textiles and, to a lesser extent, Iranian and Central Asian textiles, predominate. In recent centuries, however, Chinese textiles replaced Indian ones, at least until the Chinese Communist takeover of Tibet. For the Indian textiles in early western Tibetan contexts, see Erna Wandl, "Textile Depictions from the 10th/11th Century in the Tabo Main Temple," in *Tabo Studies II: Manuscripts, Text, Inscriptions, and the Arts,* ed. C.A. Scherrer-Schaub and E. Steinkellner (Rome: Istituto Italiano per l'Africa e l'Oriente, 1999), pp. 277–98; and Christiane Papa-Kalantari, "The Ceiling Paintings of the Alchi *gsum brtsegs:* Problems of Style," in *Buddhist Art and Tibetan Patronage, Ninth to Fourteenth Centuries,* ed. Deborah Klimburg-Salter and Eva Allinger (Leiden: Brill, 2002), pp. 85–114.

83 Nyingma Centers Art Projects, *How To Frame a Thanka: A Guide to Displaying Sacred Art and Constructing Traditional Cloth Mountings* (Berkeley: Dharma Publishing, 1989).

84 Gary Dickinson and Linda Wrigglesworth, *Imperial Wardrobe* (Berkeley: Ten Speed Press, 2000), p. 126. See also Zhou Xun and Gao Chunming, *5000 Years of Chinese Costumes* (San Francisco, 1987), pp. 152–54, 188–89; Beverley Jackson and David Hugus, *Ladder to the Clouds: Intrigue and Tradition in Chinese Rank* (Berkeley: Ten Speed Press, 1999); Stuart and Rawski, *Worshiping the Ancestors.*

85 In 1992 the author acquired in Leh just such a cape made out of a faded, yellow Qing court dragon robe.

86 These include the huge appliqué *tangkas* sometimes three stories tall. See Gyeten Namgyal with Kim Yeshi, "A Tailor's Tale," *Choyang* 6 (1994): 28–63; Nancy Jo Johnson, "The Great Applique Tangka of Drepung Monastery," 1999, www.himalayanart.org, under "textiles: exhibits: photo albums."

87 Sperling, "Early Ming Policy," pp. 156–59.

88 This account was taken from the "Verbal Report" of Purangir Gosain; see Turner, *Account of an Embassy,* pp. 458, 460, 462. Cammann discusses the "defects" of this account, which had been written down when Gosain returned to India three years after the trip in question; nevertheless, Cammann agrees "it has some very interesting information" (Cammann, "The Panchen Lama's Visit to China in 1780," p. 9).

[89] Among the many discussions of *kesi*, the best recent introduction to technical and historical issues is Watt and Wardwell, *When Silk Was Gold*, pp. 53–63.

[90] Anning Jing, "The Portraits of Kubilai Khan and Chabi by Anige (1245–1306), a Nepali Artist at the Yuan Court," *Artibus Asiae* 54, nos. 1–2 (1994): 40–86; Watt and Wardwell, *When Silk Was Gold*, pp. 95–99.

[91] On Tibetans in Hangzhou and the making of *kesi* images, see Su Bai, "Yuandai Hangzhou de Zangchuan Mijiao ji qi youguan yiji," in *Zangchuan Fojiao Siyuan kaogu* (Beijing: Wenwu chuban she, 1996), pp. 365–87. For surviving examples, see *Precious Deposits*, vol. 2, no. 44, including the *kesi* depicting Achala, which has been exhibited in Europe and the United States. Also, Watt and Wardwell, *When Silk Was Gold*, pp. 90–94; and Dan Martin, "Painters, Patrons and Paintings of Patrons in Early Tibetan Art," in *Embodying Wisdom: Art, Text and Interpretation in the History of Esoteric Buddhism*, ed. Rob Linrothe and Henrik Sørensen (Copenhagen: The Seminar for Buddhist Studies, 2001), pp. 175–76.

[92] *Precious Deposits*, vol. 3, pl. 55.

[93] Valrae Reynolds and Yen Fen Pei, *Chinese Art from the Newark Museum* (New York: China Institute in America, 1980), no. 27, p. 49, n. 1. The original collectors, Herman and Paul Jaehne, spent many years in China and Japan; presumably they acquired it there. At any rate, it was remounted in Japan. This information was kindly supplied by Valrae Reynolds in a personal communication.

[94] *Precious Deposits*, vol. 3, no. 58; also Namgyal et al., *Tibetan Buddhist Monastery*, p. 48. A related *kesi*, with many of the same motifs, entered the Art Institute of Chicago collection in 1913, acquired through the wife of the American ambassador to China in what is now Beijing. Its colors are close to the one in Tibet, though the reds have turned to orange; Art Institute of Chicago, *Clothed to Rule the Universe: Ming and Qing Dynasty Textiles at The Art Institute of Chicago* (Chicago: Art Institute of Chicago, 2000), cat. no. 53.

[95] Morris Rossabi, "The Silk Trade in China and Central Asia," in Watt and Wardwell, *When Silk Was Gold*, p. 11.

[96] The name of the monastery has been withheld to prevent unscrupulous dealers and collectors from targeting it for theft.

[97] *Precious Deposits*, vol. 3, no. 59, pp. 176–77.

[98] David Jackson and Janice Jackson, *Tibetan Thangka Painting: Methods and Materials*, rev. ed. (Ithaca: Snow Lion, 1988), p. 124.

[99] Richard M. Barnhart et al., *Three Thousand Years of Chinese Painting* (New Haven: Yale University Press, 1997), figs. 57, 60.

[100] Kiyohiko Munakata, *Sacred Mountains in Chinese Art* (Champaign-Urbana: University of Illinois, 1991), p. 135.

[101] Hargett, "Huizong's Magic Marchmount," p. 10.

[102] Barnhart et al., *Three Thousand Years*, p. 124.

[103] Another artist who used blue-and-green in a related manner, though with Daoist overtones, is Chen Ruyan (ca. 1331–before 1371). See his painting *Realms of Immortals*, in ibid., fig. 170.

[104] Shou-Chien Shih, "The Mind Landscape of Hsieh Yu-yü by Chao Meng-fu," in Wen Fong, *Images of the Mind: Selections from the Edward L. Elliott Family and John B. Elliott Collections of Chinese Calligraphy and Painting at The Art Museum, Princeton University* (Princeton: Princeton University, 1984), p. 250. Chen Ruyan painted *Mountains of the Immortals* in the blue-and-green style under the inspiration of Zhao Mengfu. Little and Eichman, *Taoism*, no. 144.

[105] Even in the more avant-garde literati circles, painters such as Tang Yin and Qiu Ying used the blue-and-green mode, sometimes in monumental hanging scrolls or in vast handscrolls. In some examples, the compositions derive from Five Dynasties and Northern Song ink landscapes, but the execution is with colorful, opaque blue-and-green pigments. See Barnhart et al., *Three Thousand Years*, figs. 211–13.

[106] Alan Atkinson, catalog entry for early sixteenth-century Arhat painting, in *Latter Days of the Law*, p. 274.

[107] De Visser, "Arhats in China and Japan" (1918/19), p. 225.

[108] De Visser, "Arhats in China and Japan" (1920–22), p. 125.

[109] Although not explored in this exhibition, blue-and-green mountain settings were used widely in Tibetan art, especially portraiture.

[110] Amy Heller, "The Paintings of Gra thang: History and Iconography of an 11th century Tibetan Temple," *Tibet Journal* 27, nos. 1/2 (2002): 45. She goes so far as to assert that it would be understood as a deliberate "allusion to teachings of Chinese Buddhism." The transliteration of the Chinese word for the ring should be *gouniu*, not, as she gives, *gouniou*.

[111] Pal compares a painting from the same set to which catalog no. 27 belongs, to an earlier Arhat painting and points out that "what little naturalism can be discerned in the earlier piece is completely eschewed here for a landscape of fantasy." Pratapaditya Pal, *Himalayas: An Aesthetic Adventure* (Chicago: Art Institute of Chicago, 2003), p. 258.

[112] See Little and Eichman, *Taoism*, pp. 147–61.

[113] Kent, "Depictions of the Guardians," pp. 184–88. Marsha Weidner also discusses these connections in *Latter Days of the Law*, pp. 268–69. For Daoist and Buddhist immortal imagery, see Marilyn Gridley, *Chinese Buddhist Sculpture Under the Liao* (New Delhi: Aditya Prakashan, 1993), p. 131. For the Seven Sages of the Bamboo Grove, see Audrey Spiro, *Contemplating the Ancients: Aesthetic and Social Issues in Early Chinese Portraiture* (Berkeley: University of California Press, 1990). For the connection to images of monks and Arhats, see Janet Baker, "Foreigners in Early Chinese Buddhist Art," pp. 68–87. Helmut Brinker discusses the background of early images of recluses like the Seven Sages of the Bamboo Grove and compares them to portraits of the Chan patriarchs, which are closely related to Arhat imagery, in "Ch'an Portraits in a Landscape," *Archives of Asian Art* 27 (1973–74): 8–29.

[114] Compare the figures and setting of the Arhats in the exhibition with the Daoist immortals in Little and Eichman, *Taoism*, nos. 123–26.

[115] Berger, *Empire of Emptiness*, p. 144, pl. 14, figs. 45, 46; McNair, *Latter Days of the Law*, p. 15.

[116] Berger, *Empire of Emptiness*, pp. 127–32, figs. 37–40.

[117] Compare to ibid., pp. 132–33, fig. 39.

[118] Confirmed in the examination by Jacki A. Elgar, head of the conservation studio, Museum of Fine Arts, Boston, 16 May 2003. On color notations, see Kate I. Duffy and Jacki A. Elgar, "Five Protective Goddesses (Pancaraksha): A Study of Color Notations and Pigments," in *Scientific Research in the Field of Asian Art: Fiftieth-Anniversary Symposium Proceedings*, ed. Paul Jeff et al. (Washington, D.C.: Archetype Publications and Freer Gallery of Art, Smithsonian, forthcoming), pp. 164–69; idem, "Examination of Thangkas from Central and Eastern Tibet," *Proceedings of the Sixth International Conference on "Non-Destructive Testing and Microanalysis for the Diagnostics and Conservation of the Cultural and Environmental Heritage,"* ed. M. Marabelli et al., vol. 3, pp. 1751–66; and idem, "An Investigation of Palette and Color Notations Used to Create a Set of Tibetan Thangkas," in *Historical Painting Techniques, Materials, and Studio Practice*, ed. Arie Wallert, Erma Hermens, and Marja Peek, preprints of a symposium 26–29 June 1995 (University of Leiden, Netherlands, 1995).

Catalog

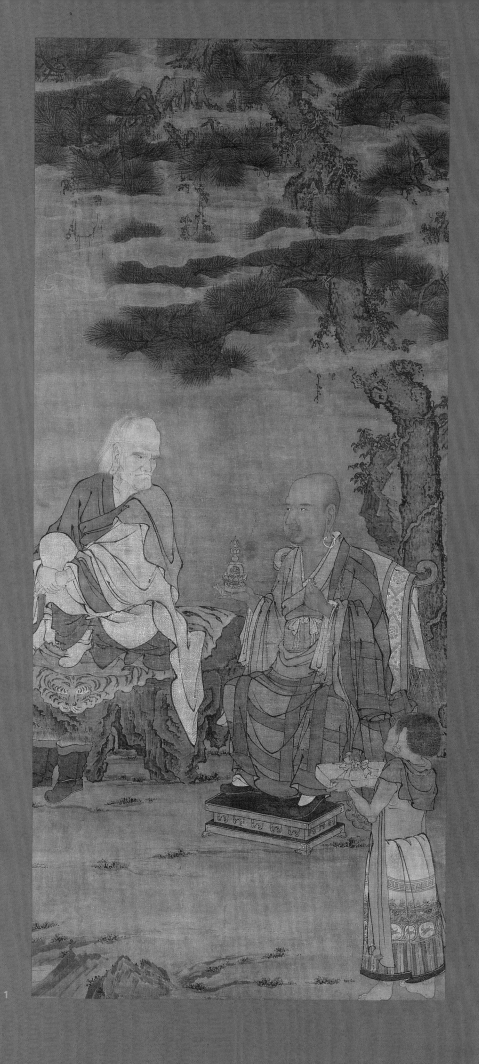

1

TWO LOHANS AND ATTENDANT
CHINA, SOUTHERN SONG DYNASTY,
13TH CENTURY
HANGING SCROLL,
INK AND PIGMENTS ON SILK
43½ × 21¼ IN. (111.1 × 54 CM)
PRIVATE COLLECTION

Two Arhats sit beneath a soaring pine tree while an attendant brings them a wrapped book. The left Arhat has an eccentric knobby forehead, jutting chin beneath a tightly set mouth, bushy eyebrows, and steely eyes. Clasping his bent right leg, he turns to look at the much darker, Indian-looking Arhat dressed in monk's robes who holds up a miniature stupa-reliquary. The left Arhat is seated on a tiger skin laid over a rock. His pose is one adopted by the Arhat Ajita in the sets of sixteen Arhats that derive from Guanxiu (832–912), the artist credited with originating the exaggerated, grotesque type of Arhat (see essay, section 2).[1] Various aspects of the painting recall Guanxiu's mode, such as the inclusion of the boots in front of the stone and the rocky base itself. The Indian-looking Arhat wears large earrings and is seated on a chair with a brocade draped over its back. In the Tibetan system of identifying the Arhats, the sixteenth, named Abheda, frequently holds a stupa-reliquary.[2]

This is the earliest painting in the exhibition. It demonstrates how well-developed the images of Arhats already were by the thirteenth century in China. The skills of a talented academic painter have been employed to create a convincing space and naturalistic treatments of trees, rocks, brocades, and faces with modeled color. At the same time, the adept brushwork is quite noticeable. Most later paintings, Chinese and Tibetan alike, maintain many of the compositional and narrative elements already present here, including the outdoor landscape setting, rocky mounts and cloth-back chairs, a diminutive attendant, and severe-looking Arhats. However, in comparison with later Arhat paintings, there is a marked absence of blue-and-green rocks. Apparently, only in the Ming did this become standard. The Yongle era set, however, two paintings of which are included in this exhibition (cat. nos. 4, 6), may have been among the first to use blue-and-green-style landscape painting as a critical and consistent element to create an appropriately exotic setting for the Arhats.

Tortuously bent and gnarled, pine trees, like the Arhats, are associated in China with extreme longevity, transformation, and magic. They are the Arhats' true natural world counterpart.

[1] For images of Ajita in this pose deriving from copies of Guanxiu's set, see Patricia Berger, *Empire of Emptiness: Buddhist Art and Political Authority in Qing China* (Honolulu: University of Hawai'i Press, 2003), figs. 38 (right), 39 (second from the right), 42; and Pratapaditya Pal, "Arhats and Mahasiddhas in Himalayan Art" *Arts of Asia* 20, no. 1 (1990): fig. 5.

[2] See John Lowry, "A Fifteenth Century Sketchbook (Preliminary Study)," fig. A35 left and p. 98, in *Essais sur l'Art du Tibet,* ed. Ariane Macdonald and Yoshiro Imaeda (Paris: Librarie d'Amerique et d'Orient, 1977); also the Abheda thematic set at the Himalayan Art Website, www.himalayanart.org, in index under "Abheda."

2

LOHAN CUTTING TOENAILS
ATTRIBUTED TO CAI SHAN
CHINA, 13TH–14TH CENTURY
HANGING SCROLL, INK ON SILK
46 × 18 IN. (117 × 46 CM)
KAIKODO, NEW YORK

[1] The relationship of this
Arhat figure with Guanxiu's
Arhats and other painting
attributed to Cai Shan are
discussed in Howard Rogers
et al., *Kaikodo Journal: Realms
of Faith* 15 (spring 2000):
78–79, 237–39.

Against a plain silk background, the Arhat in monochrome ink is placed in a simplified but evocative setting: a craggy rock, a bit of a cliff, and a weathered tree trunk and branches arching above him. His head nimbus, placed slightly off center, could be taken for the full moon behind him. There is a great variety of ink tones and brush manners, from the wet and loose strokes of the branches to the delicately controlled strokes of the hair. The tight cropping around the Arhat gives him a monumentality and intensity, contrasting with the seeming mundaneness of his activity, clipping his toenails. This type of painting, subject matter, and composition has long been associated with Chan (Zen) Buddhism, for it emphasizes the unpretentious directness and humanity of the Arhats and suggests that enlightenment is experienced in and through the phenomenal realities of existence. That unpretentious ideal, as found in the rough-hewn, unglamorous Arhat type credited to the ninth-century painter Guanxiu (832–912), is followed here (see essay, section 2).[1] The hunched pose, bushy eyebrows below a protruding forehead, and slightly irregular-shape head fit the type, along with the shaggy beard and botched haircut. The large nose and elongated earlobes hint at a foreign origin, while the sight of the ribs and clavicle lines reveal some of the punishing physical toll that the search for solitary enlightenment has taken.

This type of Arhat portrait—as opposed to the more idealized type—was very influential in China as well as in Tibet. For example, the Arhat featured in catalog no. 3, a Tibetan work made at least two centuries later, clearly shares the same model.

3

ARHAT: RAHULA
TIBET, CA. 17TH CENTURY
MINERAL PIGMENTS ON CLOTH
37½ × 23½ IN. (95.3 × 59.7 CM)
RUBIN COLLECTIONS

His robes slipping off his shoulder, his bony chest exposed, the Arhat sits patting the head of a tiger that seems to grin with delight at his touch. The tiger is particularly well painted, with a whorl of fur on its haunch. In this charming narrative, a pink-fleshed monastic acolyte watches somewhat warily from the other side of the Arhat, while a boyish attendant, coming on the scene with a Chinese-style book, hides behind the trunk of the tree.

This and other paintings in the same set (cat. nos. 15, 19; also appendix) are Tibetan in origin, despite the many informed references to Chinese painting. References to Chinese visual culture include the distinctive blue-and-green rocks in the foreground and background, the tree-framed composition, the accoutrements of book and speckled-bamboo staff, and the styles of robes (see essay). The face and body of the Arhat seem to follow the same model as the Chinese Arhat of catalog no. 2. Despite these Chinese qualities, the gold inscription (bottom, center) is in Tibetan script, which demonstrates a Tibetan patron or audience for the set. In addition, as part of the under-drawing, there are color notations in Tibetan that are visible where the opaque colors have flaked off. Such markings also indicate a Tibetan origin for the artists.[1]

The gold inscription identifies the Arhat as Rahula,[2] the tenth of the sixteen Arhats. This is rather unusual, since Rahula is more often depicted in Tibet holding a diadem (see cat. nos. 24, 25). The posture, facial expression, and bamboo staff make the Rubin Arhat more closely resemble the third Arhat of Guanxiu's set, Pindola Bharadvaja.[3] However, the Chinese and Tibetans have their own

systems of Arhat identification and ordering, neither of which is necessarily consistent, nor do they preclude confusion, a mixing of systems, or creative reinterpretations made by individual artists. (See curator's note on iconographic complications, p. 7.)

[1] Confirmed in the examination by Jacki A. Elgar, head of the conservation studio, Museum of Fine Arts, Boston, 16 May 2003. On color notations, see Kate I. Duffy and Jacki A. Elgar, "Five Protective Goddesses (Pancaraksha): A Study of Color Notations and Pigments," in *Scientific Research in the Field of Asian Art: Fiftieth-Anniversary Symposium Proceedings,* ed. Paul Jeff et al. (Washington, D.C.: Archetype Publications and Freer Gallery of Art, Smithsonian, forthcoming), pp. 164–69; idem, "Examination of Thangkas from Central and Eastern Tibet," in *Proceedings of the Sixth International Conference on a Non-Destructive Testing and Microanalysis for the Diagnostics and Conservation of the Cultural and Environmental Heritage,* ed. M. Marabelli et al., vol. 3, pp. 1751–66; and idem, "An Investigation of Palette and Color Notations Used to Create a Set of Tibetan Thangkas," in *Historical Painting Techniques, Materials, and Studio Practice,* ed. Arie Wallert, Erma Hermens, and Marja Peek, preprints of a symposium 26–29 June 1995 (University of Leiden, Netherlands, 1995).

[2] Tibetan inscription: sgra can 'dzin/ g.yon lnga pa.

[3] Patricia Berger, *Empire of Emptiness: Buddhist Art and Political Authority in Qing China* (Honolulu: University of Hawai'i Press, 2003), fig. 40; Marsha Weidner, ed., *Latter Days of the Law: Images of Chinese Buddhism 850–1850* (Lawrence: Spencer Museum of Art, University of Kansas, 1994), no. 15.

With overgrown eyebrows, dark beards, long earlobes, and eccentrically shaped heads, these Arhats often look rather scruffy, as if their bodies have paid the price for their intense efforts to become enlightened.

Through their interactions in the painting, the Arhat, tiger, monk, and attendants serve as surrogates for the viewer by demonstrating feelings of wonder and reverence.

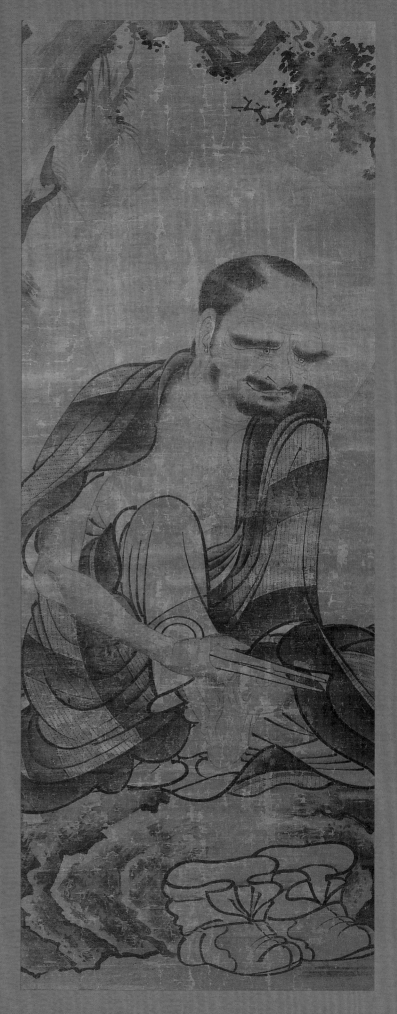

2

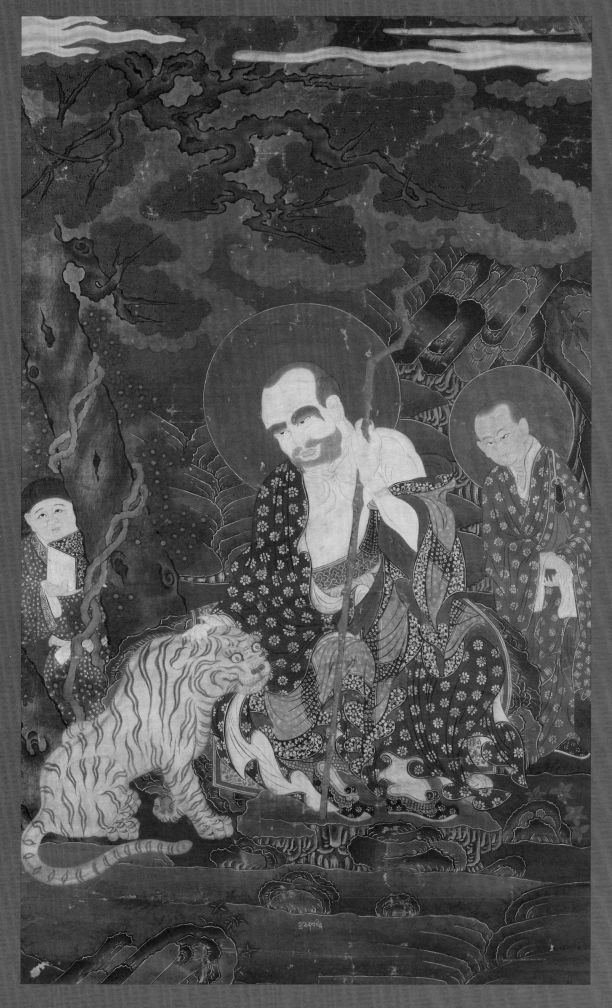

3

[1] Gisèle Croës, *Splendor of Yongle Painting: Portraits of Nine Luohan* (Brussels, 2002), p. 28. The inscription "indicates that the work was dedicated or donated during the reign of Yongle of the Great Ming."

4

ARHAT: AJITA
CHINA, YONGLE PERIOD, 1402–24
MINERAL PIGMENTS AND GOLD ON SILK
30¾ × 19¾ IN. (78 × 50 CM)
COLLECTION OF ROBERT ROSENKRANZ,
NEW YORK

5

ARHAT: CHUDAPANTAKA
TIBET, LATE 15TH CENTURY
MINERAL PIGMENTS ON CLOTH
39 × 22½ IN. (99 × 57.2 CM)
RUBIN COLLECTIONS

Both Ajita and Chudapantaka make the same gesture of meditation and so are easily confused. The owner of catalog no. 4 accepts the identification of Ajita for the Arhat, while the Rubin Arhat is identified as Chudapantaka. Admittedly, Ajita usually wears a cloth covering over his head, but there are exceptions to this, including ones that are inscribed, so the issue of identification cannot be resolved. Fortunately, since the main purpose here is the comparison of Chinese and Tibetan handling of the identical composition, the nomenclature is somewhat beside the point.

Beside entwined trunks that form a canopy over him, the Arhat sits in a calm posture on a flat-topped rock outcrop over which a patterned mat has been thrown. His sandals have been untied and removed and rest on a smaller rock in front of him. The Arhat's hands are cupped loosely in his lap, and he gazes tranquilly forward while an attendant walks down a mysterious set of steps to serve tea. A lion padding across the scene seems to have just noticed the Arhat and turns his bushy head to emit a roar of recognition. The Tibetan Arhat (cat. no. 5) looks down at the lion and smiles indulgently, while the Chinese Arhat (cat. no. 4) ignores the lion. The setting is a utopian vision of perfect beauty, flowers blooming, birds singing, and

hints of gold here and there in the landscape, particularly in the Chinese painting. The azurite blues of the blue-and-green rocks are muted to shades of green in the Tibetan painting. Otherwise, the differences between them are relatively subtle. The decoration of the brocade robes is handled differently, but the Tibetan version is only slightly less fine than the Chinese. Some of the garment folds cascading on the rock surface are perhaps less well understood in the Tibetan painting, and the colors are different. The Tibetan artist's trees are not as elegantly rendered, with a strange mottling on one and little modeling on the other. The needles are reduced from individual strokes to rounded clumps of leaves. The Chinese painting emphasizes the feeling of depth and space by adding such details as the branches of the tree overlapping the halo. As discussed below, in relation to catalog nos. 6 and 7, the major iconographic innovation made by the Tibetan artist is the inclusion of the red Amitayus image (upper right corner), a Buddha associated with longevity.

In addition to offering a unique opportunity to compare the way artists in different cultures treat an identical theme and composition, these paintings also illustrate how close the connection between China and Tibet may have been in the fifteenth century. The Chinese painting is earlier and is likely to have been completed at the Ming court during the Yongle era, as is shown by the high quality of materials and execution and by an inscription on one of the nine paintings from the set that remain together.[1] Given the practice of exchanging paintings, including Arhat sets, between China and Tibet, the Tibetan work suggests that a set of the Yongle paintings was donated to a Tibetan teacher or monastery and, in one form or another, served as models for Tibetan painters depicting the Arhats. In turn, these may have been sent to the Chinese court as gifts.

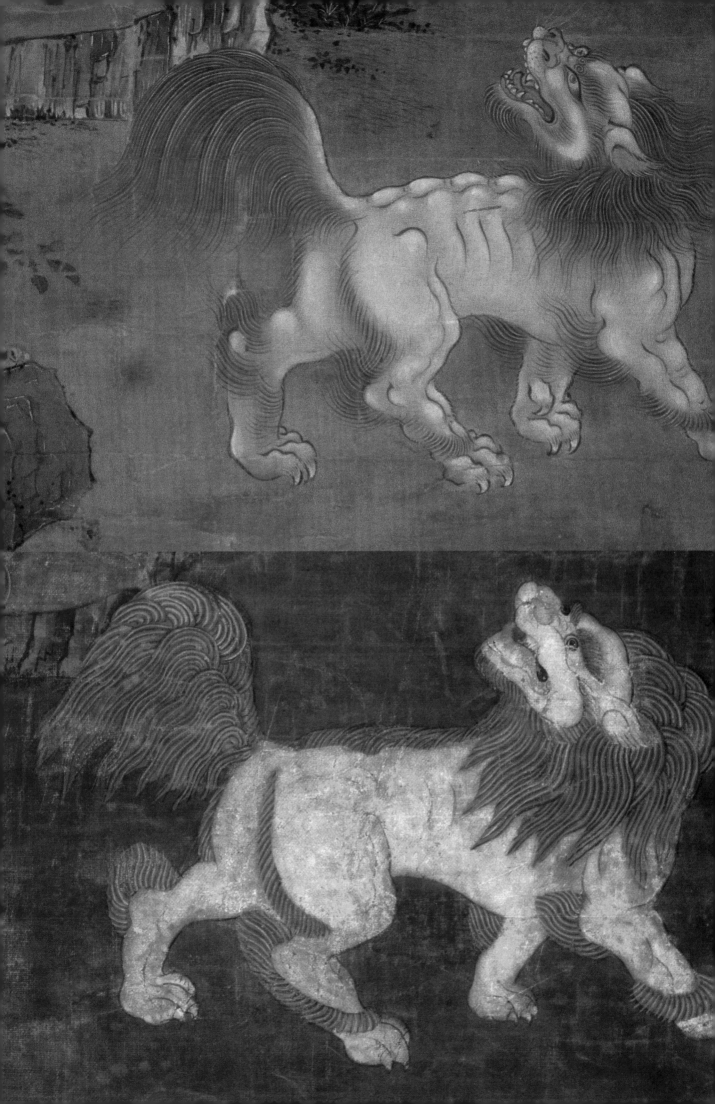

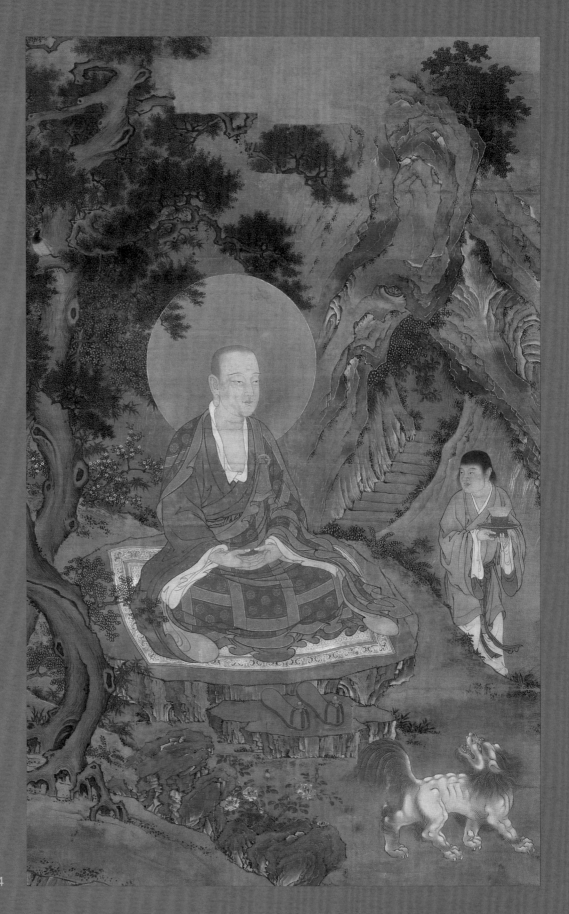

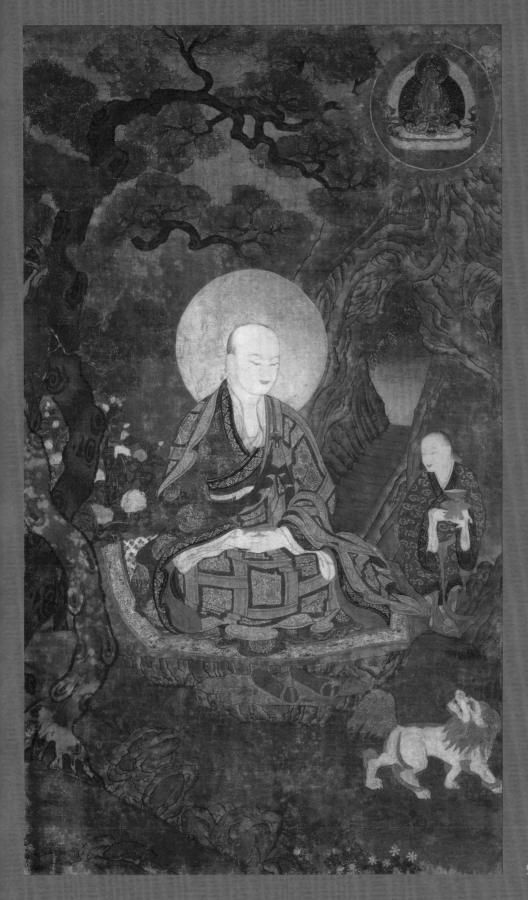

Through their solitary meditations leading to enlightenment, Arhats are believed to have acquired great longevity, if not immortality. The Arhats are especially inspirational for monks and nuns as successful models who continue to observe all monastic rules and vows.

[1] Kalika is the fourth Arhat in the Tibetan system of counting (see also cat. no. 9).

[2] Perhaps a set of Arhats, or at least drawings that could be used as models, was sent to Tibet.

[3] For instance, in a partial set of Arhat paintings in the collection of the Brooklyn Museum of Art, the same form of Amitayus seen here appears above Kanakavatsa. For an illustration, see www.himalayanart.org, item 86920. Unfortunately this set does not include Kalika for comparison, although perhaps a different deity substituted for Kalika in that set. Or, since catalog nos. 5 and 7, which appear to be from the same set (but not from the Brooklyn set), both have Amitayus, does that imply that every Arhat in the original set had Amitayus?

6

ARHAT: KALIKA
PRODUCED IN THE IMPERIAL WORKSHOPS
OF THE MING COURT
CHINA, YONGLE PERIOD, 1402–1424
MINERAL PIGMENTS AND GOLD ON SILK
30¾ × 19¾ IN. (78 × 50 CM)
COLLECTION OF ROBERT ROSENKRANZ,
NEW YORK

7

ARHAT: KALIKA
TIBET, CA. 15TH CENTURY
MINERAL PIGMENTS ON CLOTH
46¾ × 29¼ IN. (118.8 × 74.3 CM)
RUBIN COLLECTIONS

Both these paintings depict the Arhat Kalika.[1] Catalog no. 6 is Chinese and can be dated to the Yongle period, while catalog no. 7, a Tibetan painting of the identical theme and composition, was probably executed later in the same century. The Chinese painting is of very high, court quality. The colors are pure and bright, and the control of the brushwork impeccable. Lavish details and colors beautify the garments of the Arhat, his attendant, the blossoming peonies below him, and the plumage of the birds above him. The colors of the Tibetan painting are more sober. In part this is due to the restricted use of gold, which was reserved for Amitayus, the deity floating above, and the garments of the figures. In the Chinese painting, however, the facets of the blue-and-green rocks are outlined in gold. Additionally, the small flowers at the top of the middle-ground rock (left) have been transformed into a leafy bush. In the Tibetan painting, the particularized leaves of the different types of trees were also simplified, as was the texture of the tree trunk. Tree branches in the Chinese painting are gnarled and angled, while in the Tibetan version they are smoothed into curves. Similarly, in the Tibetan version, faces of the figures are older and less idealized, less sinicized than in the Chinese painting.

In terms of layout and composition, the Tibetan artist followed the design used by the Chinese painting to a remarkable degree.[2] Despite faithfulness to the overall composition, as the subject was translated into a Tibetan visual system, there was a distinct loss of the illusion of space. Tibetan painters raised the figure, moving it to a slightly more central position. The enticing void on the left of the Chinese painting, fringed with hanging vines and leading into the background, now makes little sense. The areas where the cliffs or rocks root into the earth are given a lighter shade in the Chinese painting to suggest newly exposed erosion. This is lost in the Tibetan painting, where the artist marks the junction with a flat black line. The Tibetan artist also changed the color of the two birds from red to white; there is now a symmetrical triangulation between the birds and the small seated figure in the upper left corner.

The Tibetan innovations are largely iconographic. The red deity floating in the upper left corner holding a vase of ambrosia is Amitayus, the Buddha associated with longevity. The pairing of each Arhat with a deity seems to have originated in Tibet about this time. Over time, as Tibetan iconographic systems found their way to the Qing court in China, Chinese artists began to incorporate them (see essay, section 13). More work needs to be done to determine the parameters and consistency of the identity of each pairing.[3] These iconographic issues remain unresolved, but what is clear from this comparison is that the Tibetan artists worked from a Chinese model but modified it visually and iconographically.

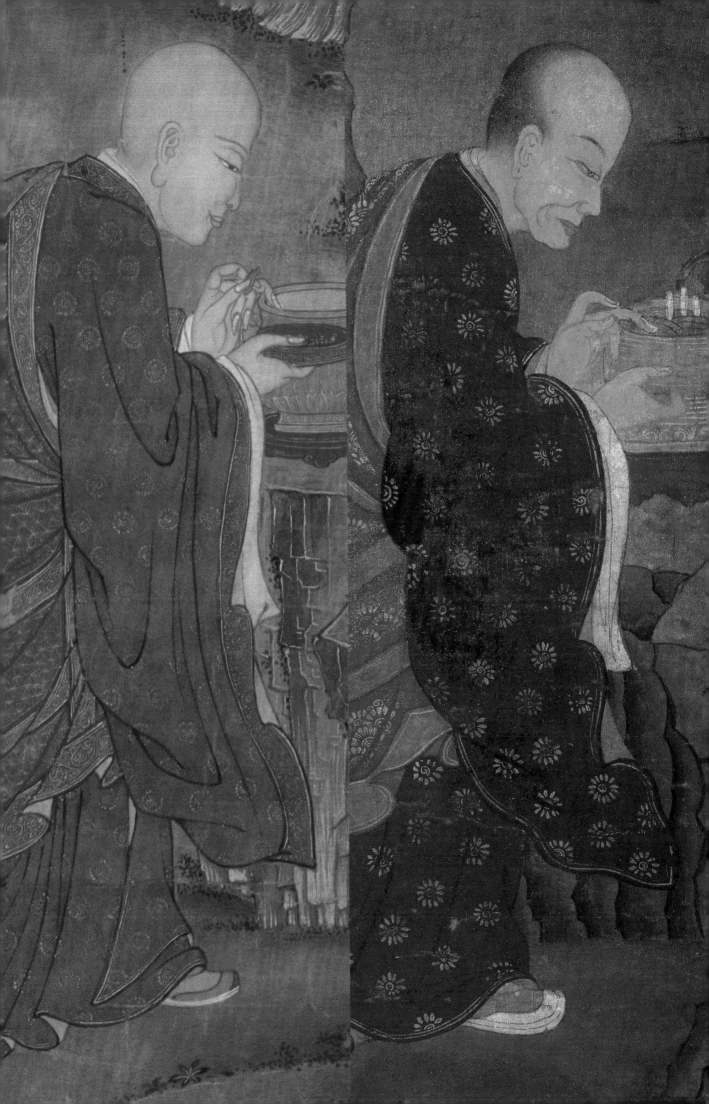

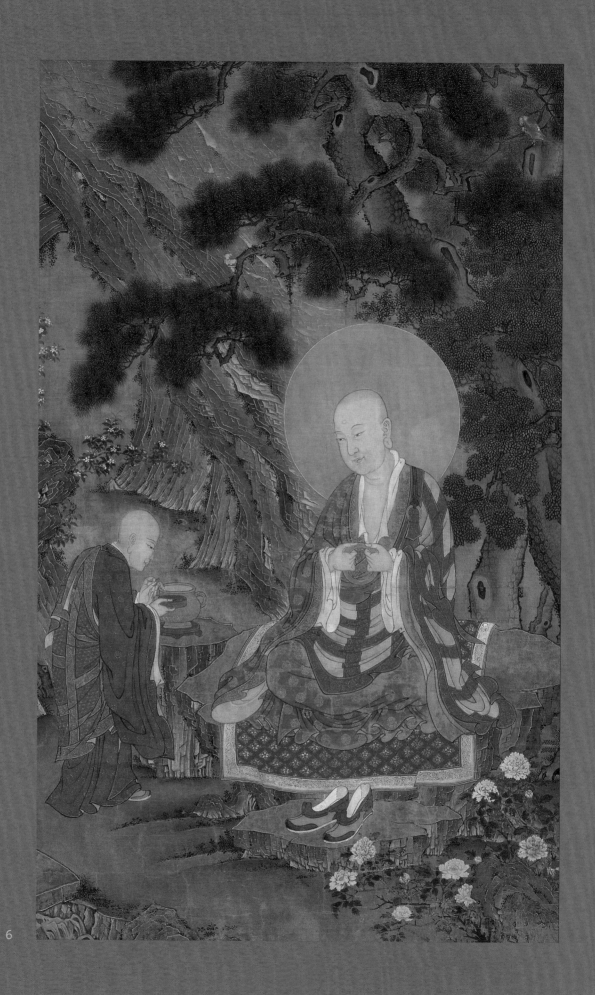

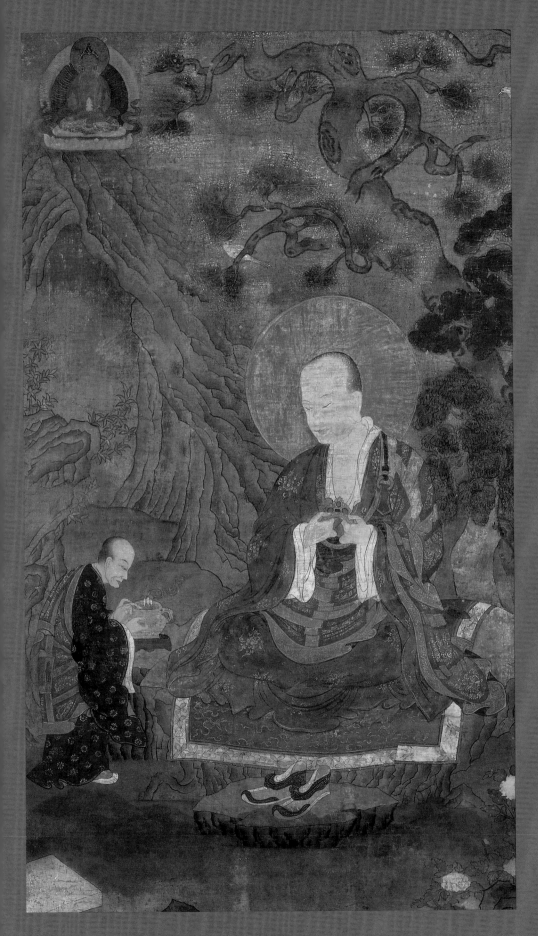

Chinese painters integrate each object into a whole, suggesting a shared atmosphere. The Tibetans give each object its due yet feel no obligation to stitch them together into a seamless whole.

7

¹ This information kindly provided by Cary Liu, associate curator of Asian Art, Princeton University Art Museum.

² See, for example, the fourteenth-century hand-scroll in the Museum of Fine Arts, Boston, published in Stephen Little and Shawn Eichman, *Taoism and the Arts of China* (Chicago: Art Institute of Chicago, 2000), pp. 220–23.

"Secular" genres of Chinese painting, such as portraiture, may have inspired Tibetan painters. At the same time, Lu Wending's appearance must certainly have been influenced by Buddhist images of teachers and Arhats.

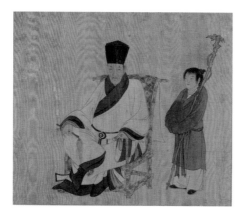

8

PORTRAIT OF LU WENDING
SHEN JUN
CHINA, 1591 (19TH YEAR OF WANLI)
ONE OF TEN LEAVES CUT FROM
HANDSCROLL AND REMOUNTED
AS ALBUM, COLORS ON SILK
SILK LEAF: 12½ × 14½ IN.
(31.6 × 36.8 CM)
PRINCETON UNIVERSITY ART MUSEUM

In this rather compelling portrait, Lu Wen-ding sits in a chair angled slightly away from the picture plane, but he stares directly back at us. His aged face, with high attenuated eyebrows, thick nose, and thin lips, looks frank but austere. The tall scholars' hat seems to contrast with the relaxed cross-legged sitting posture, and his brightly colored shoes peek out under the hem of his voluminous dark-trimmed white robe. He sits in an unpretentious bamboo chair, its seat and back draped with a flower-patterned cloth. The handle of a fly whisk is clasped in the fingers of his right hand, the tail hanging straight down against his leg. Beside him stands a young rustic attendant in a blue robe with a gnarled liana-wood staff ending in a dragon-head finial.

This painting is now an album leaf, one of ten portraits of Lu Wending in different guises. Originally, they were all part of a continuous handscroll, but an inscription states that a sixth-generation descendant of Lu Wending made the handscroll into an album in 1798 for ease of looking and care.¹ Such portrait series are not unusual, mixing costumes and settings and sometimes even ages of the sitter.²

9

ARHAT: KALIKA
TIBET, CA. 18TH CENTURY
MINERAL PIGMENTS ON CLOTH
21¼ × 15¼ IN. (54 × 38.7 CM)
RUBIN COLLECTIONS

Like catalog nos. 6 and 7, this is Kalika,[1] the fourth Arhat in the Tibetan system of counting. This is evident from the pair of earrings he holds in his right hand, as earrings are Kalika's primary attribute. The earrings are the Arhat's reward for visiting one of the heavens and teaching the Buddha's *dharma* (truth, path to enlightenment) to the assembled gods there. Out of gratitude, they offered him a large number of gifts, which he transformed into a single pair of gold earrings.[2]

In contrast to the other Tibetan depiction of Kalika in the exhibition, which is Chinese in figure and setting (cat. no. 7), this Kalika has a number of Tibetan genre elements. The face and bare arm of the Arhat are quite closely observed in terms of anatomy. The parallel lines etched around his mouth, his thin beard, and the musculature of his shoulder are impressively rendered. A lazy monk daydreams below the chair (left), tapping his fingers distractedly on one of the wooden struts. A younger monk with a beard, which, except for its dark color, resembles the Arhat's, instructs a nearly naked ascetic and another monk in front of his cave-retreat (top right corner). Before the Arhat stand five men. The nearest one, in an archaic Chinese-style imperial headgear, offers the Arhat a golden wheel. Of the four others, two offer brocade-wrapped books, a third an ivory tusk, and the fourth seems to overturn a reed basket of the type used to cage birds. At the lower right, by the Arhat's boots—with the upturned toes revealing stitched soles—a gray goat, yellow-eyed, stands immobile, offering the Arhat an extraordinary, round, scarlet fruit or flower, the stalk of which the goat holds in his mouth.

The wild goat's offering from the natural world recalls the *ruiying*, or auspicious signs, discussed in the introductory essay as an important Chinese mode of thought adopted into Arhat painting (see essay, section 3). Among the many other Chinese elements in this painting are the renderings of the branches of what resemble hibiscus flowers and, in particular, of the chair on which the Arhat sits. It is made of knotty branches of wood roughly lashed together, and in design, if not material, the form is comparable to the chair in which Lu Wending sits (cat. no. 8). Under the rich cloth draped over it, the top rung of the chair-back ends in long angled extensions that almost become armrests. Both have terminal dragonlike heads similar to the finial on the staff held by Lu Wending's attendant.

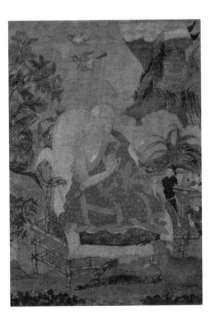

1 Tibetan inscription: g.yas dus ldan gsum pa.

2 Loden Sherap Dagyab, *Tibetan Religious Art* (Wiesbaden: Otto Harrassowitz, 1977), p. 80.

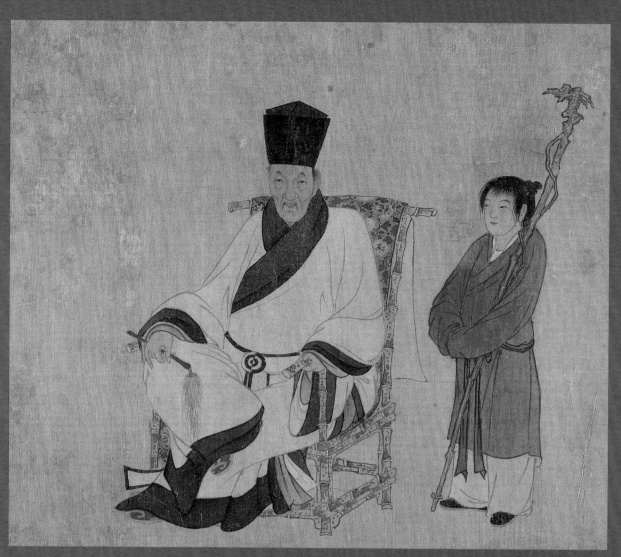

8

FACING PAGE

It is this kind of appropriate response from the animals—and even from the flowers, which seem to burst into bloom in the presence of the Arhat— that sacralizes the space.

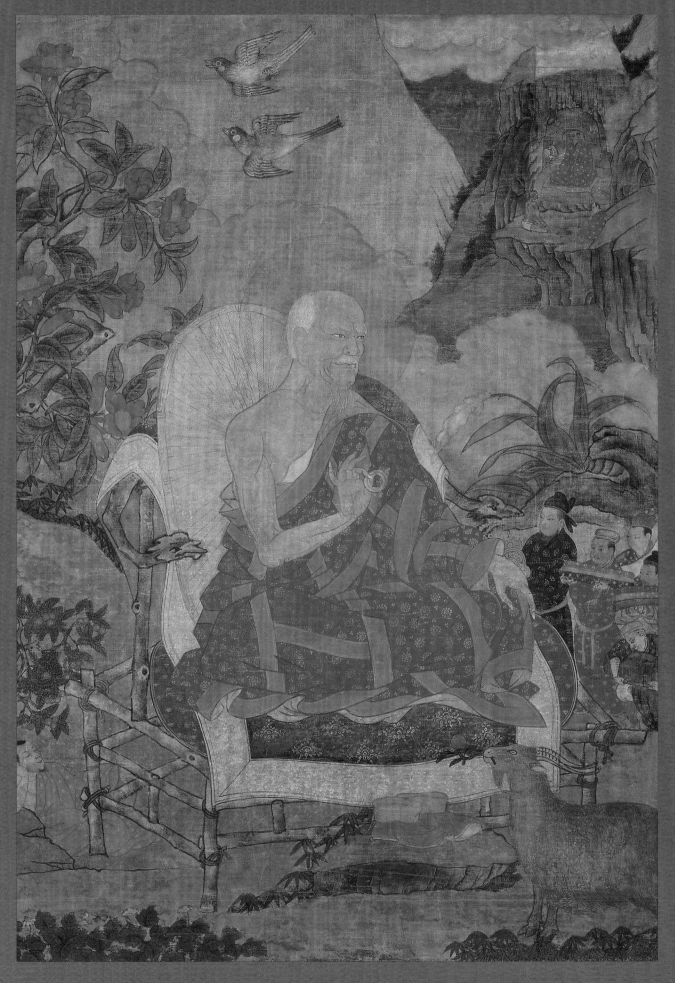

*Chairs, stools, and other
furniture figure among
the lists of gifts sent to
various Tibetans in the
early Ming and Qing.*

10

10

INCENSE STAND (XIANGJI)
SUZHOU, CHINA, 16TH–17TH CENTURY
NANMU WOOD
HT. 32½ IN. (82.6 CM)
CHAMBERS FINE ART, NEW YORK

This elegant square incense stand rests on cabriole legs that resemble a leaf curled around a ball. The cusped apron and delicate ornament on the waist resemble the Chinese furniture featured in seventeenth-century Tibetan Arhat paintings, such as catalog nos. 15 and 19. Incense stands of this type would have supported censers like the Northern Song tripod (cat. no. 11) and were used in the same ways depicted in the Arhat paintings.

11

TRIPOD CENSER
CHINA, JIN DYNASTY, 1115–1234
STONEWARE, GLAZE
6¾ × 6¾ IN. (17.1 × 16.8 CM)
BROOKLYN MUSEUM OF ART

The shape of this Northern Song–Jin dynasty vessel resembles ancient Chinese bronze ritual vessels, particularly the *ding*, another tripod form. There was a vogue in the late Northern Song court for archaistic references, and this vessel would have loosely recalled high antiquity even as it performed its function as an incense burner. The wide body constricts inward at the neck and then flares out again at the lip. Each leg is turned into a lion's mask. Except for the lack of "ear-handles," this shape became one of the variants within the standard set of altar garniture for Chinese temples.[1]

Incense burners would have been packed with sand and hot coals, over which powdered incense would be poured. Alternatively, barklike pieces of fragrant wood or resins would be lit and inserted upright into the sand. In catalog nos. 6 and 7, a broad-bellied vessel reminiscent of Shang- and

Zhou-period *gui* (ritual grain vessels) is used as an incense burner on the rock beside the Arhat. The attendant is adding charcoal or incense to the interior. Although it is difficult to determine whether the painted incense burners are intended to represent metal or porcelain, they resemble this vessel in color and shape. As it is a light olive-green glazed stoneware, it is likely from northern China, from the Yaozhou kilns.

Chinese vases on altar tables, including tripod incense burners, reflect the patron's desire to honor the Arhat with precious objects. Fine Song- and Ming-dynasty porcelains as well as stoneware were collected in Tibet.

[1] Jan Stuart and Evelyn S. Rawski, *Worshiping the Ancestors: Chinese Commemorative Portraits* (Washington, D.C.: Freer Gallery of Art and Arthur M. Sackler Gallery, 2001), p. 47, fig. 1.6.

11

[1] Cited in Eleanor Olson, *Catalogue of the Tibetan Collection and Other Lamaist Articles*, vol. 4 (Newark: Newark Museum, 1961), p. 52.

[2] Captain Samuel Turner, *An Account of an Embassy to the Court of the Teshoo Lama in Tibet* (1800; reprint, New Delhi: Manjusri Publishing House, 1971), pp. 381, 448.

12

TREE
CHINA, 19TH CENTURY
NATURAL CORAL
HT. 30¼ × 14 × 8 IN.
(76.5 × 35.5 × 20.3 CM)
BROOKLYN MUSEUM OF ART

Coral trees were imported via India to China, where they were valued since at least the Eastern Han dynasty (25–220 C.E.). In Tibet, Marco Polo attested to the demand for coral in thirteenth-century Tibet for both religious and secular purposes.[1] It is one of the items Samuel Turner listed as being traded from Tibet to China in the eighteenth century. At the same time, coral is mentioned in a letter from the Qing-dynasty Qianlong emperor (r. 1736–96) to the Dalai Lama as among the gifts delivered to the latter.[2] The taste for coral is undiminished in Tibetan culture.

The delicate pink color of this coral tree reflects Chinese tastes more than Tibetan. However, large numbers of Tibetan paintings depict coral trees in vases on offering tables. Clearly, Tibetan artists understood the coral tree as a gift appropriate for marking the respect in which deities, Arhats, and teachers were held (see essay, section 5 and figs. 16–18).

13

ARHAT: ABHEDA
TIBET, CA. 16TH CENTURY
MINERAL PIGMENTS ON CLOTH
32 × 20 IN. (81.3 × 50.8 CM)
RUBIN COLLECTIONS

Under the canopy of ancient pine trees through which a pair of birds flit and perch, the Arhat Abheda[1] gazes at the golden stupa-reliquary he holds in his hands. Vines cling to the pine trunks, and bamboo grows near the roots. A tiny Buddha figure is visible inside a trilobed niche on the curved body of the stupa. The Arhat is pictured as an old man, craggy in appearance, the outlines of his ribs showing on his chest. Over white and blue robes, he wears a stole attached at his shoulder, Chinese-style, with a jade ring and green cord. He sits on a rocky outcrop that is covered with an animal skin. Beside him, a convenient, if bizarre-looking flat-topped blue-and-green rock provides a stand on which to place a tripod censer, Chinese-style book with a blue cover, and narrow-necked *hu* vase containing a coral tree like the one in catalog no. 12. A bearded, turbaned acolyte holding a gilded pitcher stares frontally out at us. His large earrings, decorated girdle, and tooled boots brand him as a foreigner, probably a generic Central Asian. A meandering river flows down from the greenish hills in the background. Behind these hills, the artist has outlined a single sharp crested peak as if to indicate snow.

The relatively high degree of spatial illusionism and the deftly modulated outlines of the tree trunks, as well as the thorough knowledge of Chinese cultural forms, inevitably raise the question of whether this is a Tibetan or Chinese painting. To the extent that one can generalize, because the painting ground material is cotton, not silk, this may be a Tibetan painting or may at least have been painted in Tibet. At any rate, this painting is an excellent illustration of the complex relationship between some Chinese and Tibetan Arhat paintings. If it is Tibetan, it was done by someone who relied not only on Chinese landscapes, Arhat figure types, and ritual objects but also on Chinese brush manners.

Iconographically, we are on firmer ground, since the stupa-reliquary is a well-established attribute of Abheda, the sixteenth Arhat in the Tibetan system of ordering the Arhats. He is said to have been given the stupa by Shakyamuni himself when Abheda set off for a land inhabited by *yakshas,* troublesome nature spirits. The object's magical properties are such that "whoever sees, touches, or meditates on [the stupa] will have all his wishes fulfilled."[2]

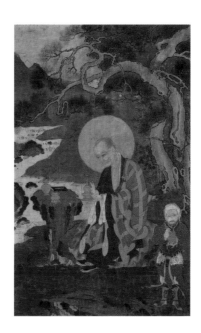

[1] Tibetan inscription: g.yon brgyad pa mi phyed pa.

[2] Loden Sherap Dagyab, *Tibetan Religious Art* (Wiesbaden: Otto Harrassowitz, 1977), p. 110.

Coral, along with gold, silver, lapis lazuli, crystal, and pearls, was one of the sapta ratna, *the seven precious objects that Buddhists are encouraged to offer to Buddhist images.*

The artist's ethnic identity, the place of production, the materials, the painting style, and the largely unrecorded history of the evolution of compositions—such unknowns often make attribution of these paintings to China or Tibet complicated.

12

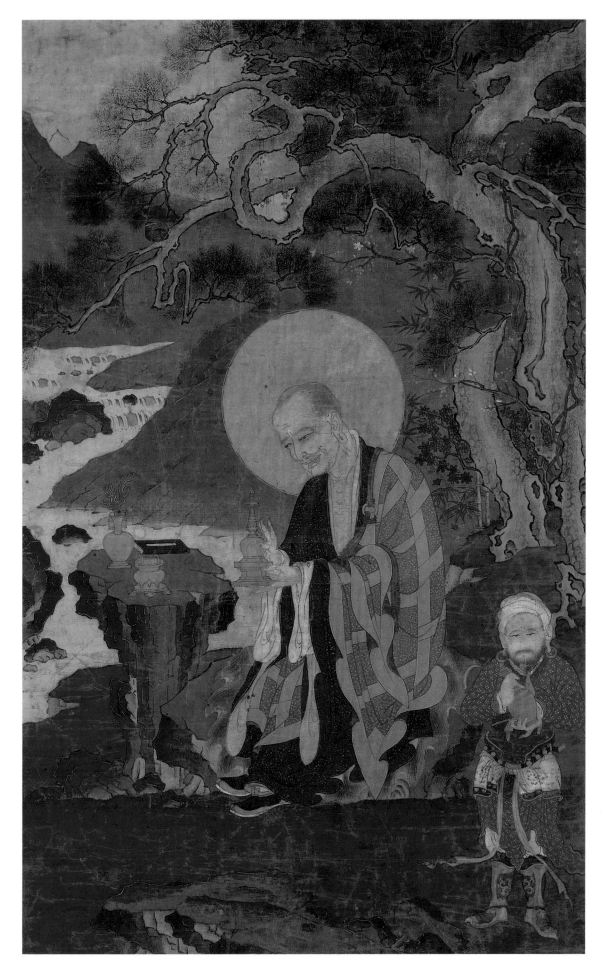

14

**BLUE-AND-WHITE *HU* VESSEL
WITH RING HANDLES
PORCELAIN VASE IN THE FORM OF
AN ARCHAIC BRONZE**
CHINA, MING DYNASTY, WANLI ERA,
1578–1619
PORCELAIN, UNDERGLAZE
8 × 4 × 4 IN. (20.3 × 10 × 10 CM)
BROOKLYN MUSEUM OF ART

In Tibetan paintings, precious objects lent an air of refinement, taste, and perhaps even status, for a visit to China was often reserved for the highest echelons of Tibetan monks and teachers.

[1] See the examples in Valrae Reynolds et al., *From the Sacred Realm: Treasures of Tibetan Art from the Newark Museum* (Munich: Prestel, 1999), pls. 40, 68, 69.

This elegant porcelain vase with its vivid dragon pattern is an example of the Chinese ceramic wares that were prized not only in Tibet but all over the world. Tibetans were the recipients of many gifts of Ming and Qing court-produced vessels, some of which are still preserved in Tibetan monasteries (see essay, section 5). Sets of teabowls with matching stands were especially prized, as were vases of this type into which flowers or other offerings could be arranged and placed on an offering table. Several Tibetan paintings incorporating Chinese ceramics are included in the exhibition, where they suggest discriminating taste and precious objects offered to the Arhats (cat. nos. 13, 15, 19).

Made in the late-Ming Wanli period, the vase displays a wide vocabulary of ornamental bands. Those on the neck recall pointed leaves, while others are more abstract. The shape itself is an archaistic reference to Bronze Age ritual vessels, renewed regularly and adapted to various media. The five-clawed dragon also appears in textile and painted form, becoming a near-eponymous emblem of China. In Tibet, the imported motifs become associated with auspicious power and were applied to a wide variety of objects, including banners, canopies, rugs, and furniture.[1]

14

[1] Tibetan inscription: 'phags pa ser be'u.

[2] Personal communication, Carol Conover, Kaikodo, New York.

[3] R. J. King, "Azurite and Malachite," *Geology Today* 17, no. 4 (2001): 152–56; see also www.minerals-n-more.com/ Azure_Mala_Info.html.

15

ARHAT: KANAKAVATSA
TIBET, CA. 17TH CENTURY
MINERAL PIGMENTS ON CLOTH
37 × 23 IN. (94 × 58.4 CM)
RUBIN COLLECTIONS

Kanakavatsa,[1] who is clearly identified in a Tibetan inscription beneath his chair, is the seventh Arhat in the Chinese system and the second according to Nandimitra (see essay, section 1). Although in Tibet, Kanakavatsa is usually shown with a string of precious stones given to him by a *naga* (a serpent-hooded demigod), here he holds a long-handled incense burner, to which he is just about to add a barklike piece. An acolyte, apparently the treasure keeper, has a key hanging from his cloth belt. He has unwrapped a book from its brocade cover and hands it to the Arhat as if he has just removed it from its locked cabinet. A dwarfish little figure stands on tiptoe to offer the Arhat peaches from a golden bowl. The Arhat sits on a lashed speckled-bamboo chair with a cloth thrown over its back. To his side is a cinnabar-lacquer incense table (compare catalog no. 10), on which stands a green archaistic bronze vessel (a *jue*) and a gilt square *hu* vase with ring handles (compare catalog no. 14) bearing stalks of plants and pieces of *lingzhi,* the so-called fungus of immortality, a Chinese convention. In the lower left corner is a tray landscape bearing a three-peaked blue foraminate mountain (see essay, section 4, and fig. 11).

In Chinese Arhat painting, the setting frequently incorporates a tree to frame the composition (compare cat. nos. 1, 2, 4, 6). The clump of bamboo in the back left is also a common feature, as are the cusped blue-and-green garden rocks in the foreground and middle ground. However, the treatment of the sky and clouds is more familiar in Tibetan painting. Since Tibetan script is used for the color notations underneath the pigments, this painting and others in the set (see appendix), were clearly made in a Tibetan workshop (see entry for catalog no. 3). At the same time, the Tibetan artists were deeply conversant in Chinese material culture.

16

"SCHOLARS' ROCK"
CHINA, NOT DATED
AZURITE WITH MALACHITE
HT. 7 IN. INCLUDING STAND (17.8 CM)
COLLECTION OF TRAVIS A. KERR

This crusty blue rock is streaked with forest green. It is actually a specimen of azurite and malachite, acquired from China, and bears a resemblance to scholars' rocks such as catalog no. 18. This connection was clearly appreciated, and a wooden stand such as those used for scholars' rocks was created. Thus it is both a scholars' rock and a geological specimen and has been exhibited as such.[2] Azurite and malachite are chemical twins, both copper carbonates, and occur together frequently.[3] Artists in China and Tibet ground azurite and malachite into powder for their green and blue pigments, which they then used in paintings of garden rocks, scholars' rocks, or tray landscapes as in catalog nos. 13, 15, 19, and 20.

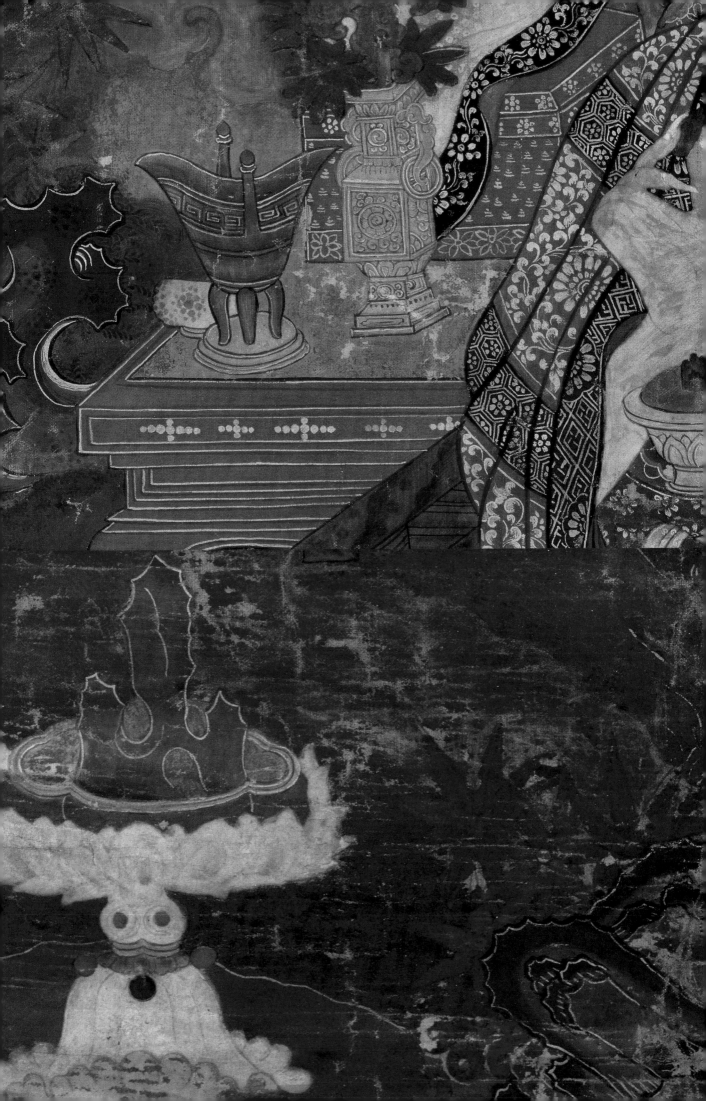

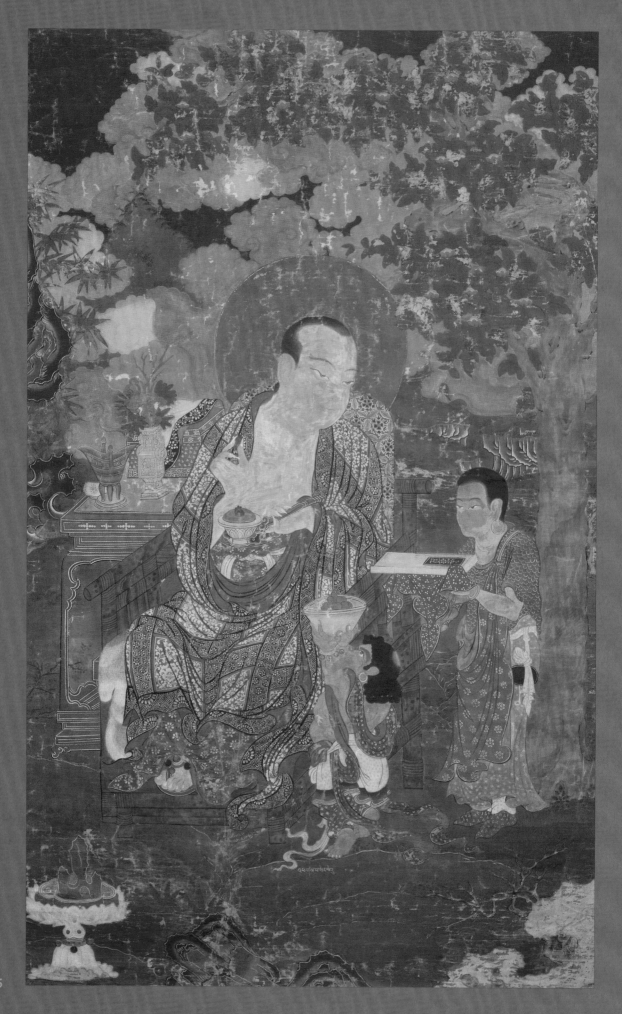

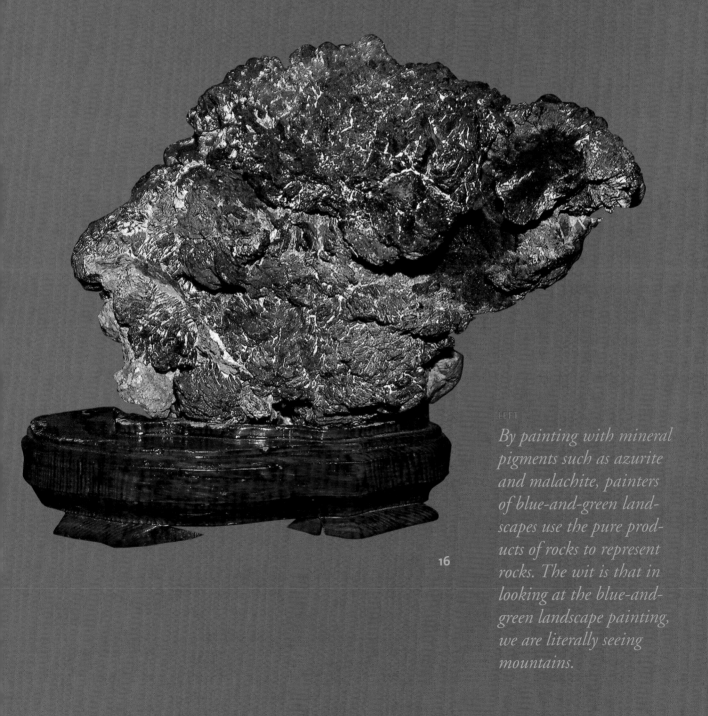

FACING PAGE
As luxury objects— commodities to be bought and sold—tray landscapes (see bottom left corner) were paradoxically signs of an inner cultivation and taste that cannot be bartered, emblems of one's unfilled aspirations, one's affinities to an ideal life in nature.

LEFT
By painting with mineral pigments such as azurite and malachite, painters of blue-and-green land- scapes use the pure prod- ucts of rocks to represent rocks. The wit is that in looking at the blue-and- green landscape painting, we are literally seeing mountains.

17

1 The connections between Arhats and dragons are discussed in the catalog entry for a Yuan-dynasty fourteenth-century Arhat painting before whom two dragons manifest themselves. See Marsha Weidner, ed., *Latter Days of the Law: Images of Chinese Buddhism 850–1850* (Lawrence: Spencer Museum of Art, University of Kansas, 1994), no. 19, pp. 270–71.

2 Loden Sherap Dagyab, *Tibetan Religious Art* (Wiesbaden: Otto Harrassowitz, 1977), p. 93.

ARHAT: KANAKABHARADVAJA
**EASTERN TIBET, 18TH CENTURY,
MINERAL PIGMENTS ON CLOTH
31 × 21 IN. (78.7 × 53.3 CM)
RUBIN COLLECTIONS**

Kanakabharadvaja is the eighth Arhat in the Tibetan set, the third according to Nandimitra (see essay, section 1). He folds his hands in quiet contemplation, his canonical gesture. The vast reservoir of the Arhats' wisdom and goodwill—notably, in producing rain—is symbolized by a dragon who has swooped into the scene, trailing clouds and bearing a tray with cusped walls holding an overflowing pitcher.[1] In front of the Arhat's throne (right) is a row of jewels and a tree of coral suggestive of treasure offerings (see essay, section 5). A basket swelling with splashing water bears a pair of scaly, bewhiskered carp, one of the auspicious items in a standard set common to China and Tibet. At the Arhat's side are two small monk-attendants, amazed by the miraculous events. Kanakabharadvaja wears an outer robe or stole in the Chinese style, attached below his proper left shoulder with a ring.

The Arhat dominates the space by his size and centrality as well as the large orange nimbus behind his broad head. The most striking aspect of the composition is the unique, pale blue-green cliff behind the Arhat. Rising relatively straight up the left side, it begins to widen toward the right at the top of the painting. The cliff is structured with a series of outlined, crystal-like facets that recall those of scholars' rocks (cat. no. 18). A craggy juniper or mimosa has found purchase among its crevices along with other flowering shrubs and scrubby bamboo at its base. The flowers lead intriguingly toward a portal, or cave-like opening, and seem to flourish beyond our sight. Although the cavern is a familiar aspect of garden-rock typology, in this case it may have been consciously married to an aspect of Kanakabharadvaja's lore. According to Dagyab Rinpoche,

> [In the center of Kanakabharadvajra's dwelling place] is a high and spacious mountain by the name of Dus-ldan. On this mountain there is said to have been a cave of precious elements which glittered lustrously. Here lived five hundred sage hermits.[2]

Perhaps the implication in the painting is that five hundred more sagely meditators are to be found beyond the cliff portal.

A dragon bursts onto the scene. The Arhat watches calmly while his two disciples appear shaken; one wipes his brow in disbelief. These are playful additions that insert a kind of psychological narrative into the paintings.

18

ROCK MOUNTAIN
CHINA, LATE MING OR EARLY QING,
1368–1644
STEATITE
15¾ × 10 IN. (40 × 25.5 CM)
HEIGHT WITH STAND 17.5 IN. (45.1 CM)
BROOKLYN MUSEUM OF ART

To appreciate gardens and rocks, one must have hills and valleys in the breast. That is to say, although most people lived in increasingly urbanized spaces, strange rocks allowed them to fantasize a very different kind of life, in remote mountains by pure streams.

The irregular shape may look like a fortuitous accident of nature, but ironically, the purplish steatite has been shaped by a sculptor to enhance its "naturalness." The crystal-like facets seem to surge upward as if giving witness to the geological forces that formed it. The fact that the strong vertical movement ends with a turn back in on itself is especially prized, as are the crevices, which allow one to fantasize about scale, imagining the rock as a huge cliff with caves. Held in an irregular wooden stand with its own caverns, the rock would have been arranged on a scholar's desk, an emblem of a retreat into nature, profound philosophy tinged with yin-yang and Daoist notions. In Ming and Qing China, scholars' rocks like this one were bought, sold, and collected as a cultural commodity. Larger versions were placed in gardens. They appear in Chinese and Tibetan paintings, both secular and religious, and must have been familiar to Tibetans after their trips to the courts of China (see essay, section 4).

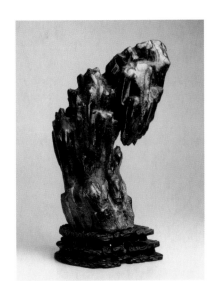

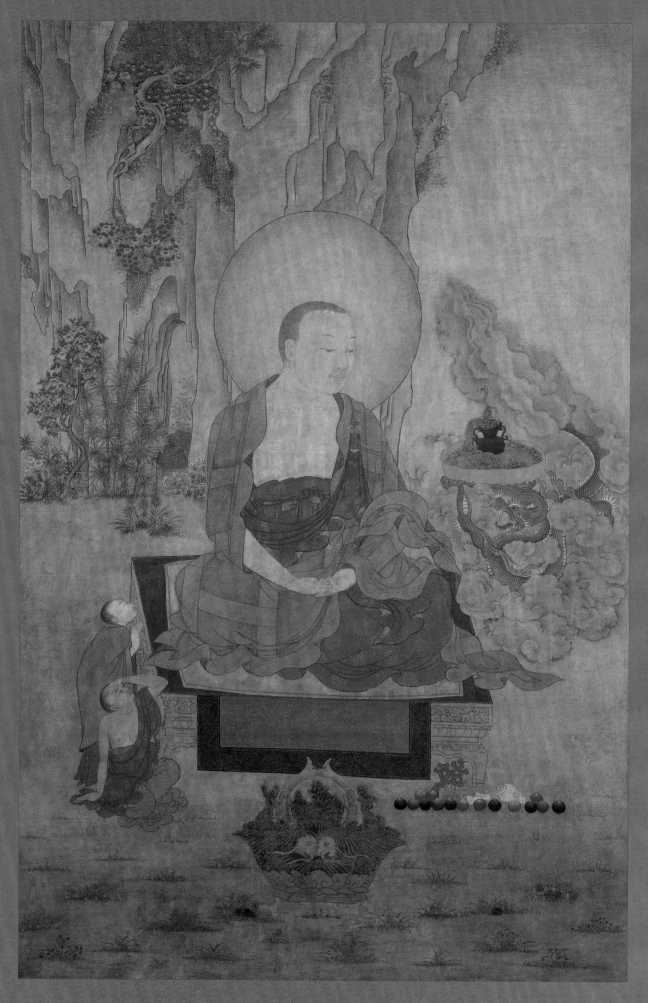

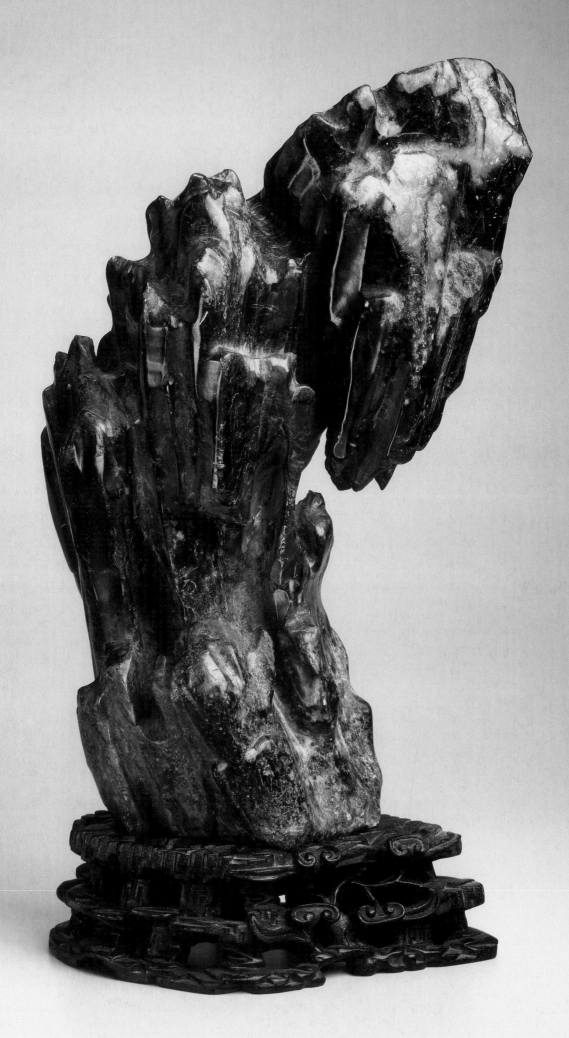

19

ARHAT: PANTAKA
TIBET, CA. 17TH CENTURY
MINERAL PIGMENTS ON CLOTH
37½ × 23½ IN. (95.3 × 59.7 CM)
RUBIN COLLECTIONS

[1] National Palace Museum, *A Special Exhibition of Paintings of Lohans* (Taipei: National Palace Museum, 1990) no. 9; also Palace Museum (Beijing), *A Selection of Ming Dynasty Court Paintings and the Zhe School Paintings* (Beijing: Cultural Relics Publishing, 1983), no. 55.

[2] Tibetan inscription: 'phags pa lam bstan.

[3] Compare additional images of Pantaka on the Himalayan Art Website, www.himlayanart.org.

[4] Stephen Little and Shawn Eichman, *Taoism and the Arts of China* (Chicago: Art Institute of Chicago, 2000), nos. 46, 73.

While the exact date and provenance of the incomplete set of Rubin and Kumar Arhat paintings (see appendix) are still in debate, there is no question that they were executed by Tibetan artists who had a deep understanding of Ming academic painting and Chinese culture generally. Tibetan, and not Chinese, patronage is demonstrated by the fact that there are Tibetan inscriptions identifying each Arhat on the front of each painting. More conclusive evidence of the artist's ethnicity are the color notations in Tibetan script underneath the pigments, visible here and there where paint has flaked off (see entry for catalog no. 3). While we can assume Tibetan artists painted this *tangka,* many details speak of an intimate knowledge of Chinese material culture. The cinnabar-lacquer tray table, porcelain cup and cup-holder, blue-and-green garden rocks, and flowers relate to Chinese luxury objects and landscape and bird-and-flower painting. The basic form of the Arhat recalls Chinese Arhat painting (cat. nos. 1, 2). The youthful acolyte peeking through the nearly closed doors is a motif that the Chinese painter Dai Jin (1388–1462) made famous in a loose-ink Arhat painting now in the Palace Museum of Taiwan.[1] Even the ring handles on the doors are similar. Still, the starburst patterns drawn in gold on the upper-left rock surfaces are not typical of Chinese blue-and-green rocks.

Pantaka,[2] whose Tibetan name is inscribed in gold below him, is the thirteenth of the Arhats in the Tibetan system, and the tenth based on Nandimitra's text (see essay, section 1). Canonically, he should carry a book,[3] but in this case, a Chinese *ruyi* (wish-fulfilling) scepter is substituted. None of the Arhats in the famous early set by Guanxiu, or later copies, carry such an implement.

However, images of Daoist deities and portraits of Daoist priests show the *ruyi* held in a similar fashion to the way Pantaka holds it in the Rubin image.[4] It conveys both authority and the control over the means to the fulfillment of wishes. Literally, the term *ruyi* means "as you wish," and from an early period in Chinese cultural history it has been something of an equivalent to the Buddhist "wish-fulfilling jewel." The fact that Tibetan artists could integrate so many features related to Chinese culture and have them intelligible to a Tibetan audience suggests considerable sophistication on the part of patrons and artists alike.

The Arhat watches impassively as the peacocks dance in front of him. The servant boy surreptitiously observes the peacocks (or us?) from behind the doors, as if afraid the peacocks might fly away were they to see him coming.

20

PEACOCK WITH FLOWERS AND
FANTASTIC ROCKS
CHINA, QING DYNASTY, 17TH CENTURY
HANGING SCROLL,
INK AND COLORS ON SILK
53¾ × 34 IN. (136.5 × 86.5 CM)
MINNEAPOLIS INSTITUTE OF ARTS

With flamboyant, bombastic abandon, the ostentatious array of an Indian peacock is in full display within a setting that equally demands our attention. In all aspects, the painting features the most fantastic of the natural: iridescent feathers, rocks marvelous in form and color, the heady aroma of roses mixing with peonies growing violet, pink, and white from the same bush, their heavy heads weighing down thick, woody stalks, and delicate magnolia blooms budding on branches opposite a stand of bamboo. It is a window to a fairytale garden consummated in precise detail, "a garden of earthly delights that will not pass away."[1] In many ways, it relates to late Ming tastes of conspicuous consumption, though the hard edges of its execution, clarity of each feature, compulsive ink dabbing to texture the ground, and turquoise moss-dots along the contours of the rock may speak of a slightly later date in the seventeenth century, after the Manchu conquest of China and installation of the Qing dynasty in 1644.

Two prominent auspicious features in the painting—a peacock, a rarity imported to China as exotic tribute, and the garden rocks (see essay, section 4)—lead us to believe that the painting "would thus have been a particularly apt gift for some high official, an end user worthy of the craft displayed in the creation of this striking image."[2] For our purposes, it also spectacularly brings together the namesake qualities of the exhibition title: paradise—through the utopian and cosmic associations of blue-and-green painted rocks—and gorgeous plumage. These features impressed Tibetan visitors to the Ming and Qing courts, in the art and in the gardens, and ultimately found their way into prominence in Arhat paintings. One example is catalog no. 19, in which a pair of peafowl stroll before the Arhat Pantaka, behind whom stalks of peonies (right) spring from a cusped blue-and-green garden rock outlined in gold, as in catalog no. 20.

Among favorable portents and signs was the unexpected appearance of birds and wild animals. Some of these birds and beasts would innately recognize an imperial presence and appear unafraid before him. In such paintings, then, we are given an "emperor's-eye view" of the imperial garden.

[1] Howard Rogers et al., *Kaikodo Journal: Worlds of Wonder* vol. 20 (autumn 2001): 100.

[2] Ibid.

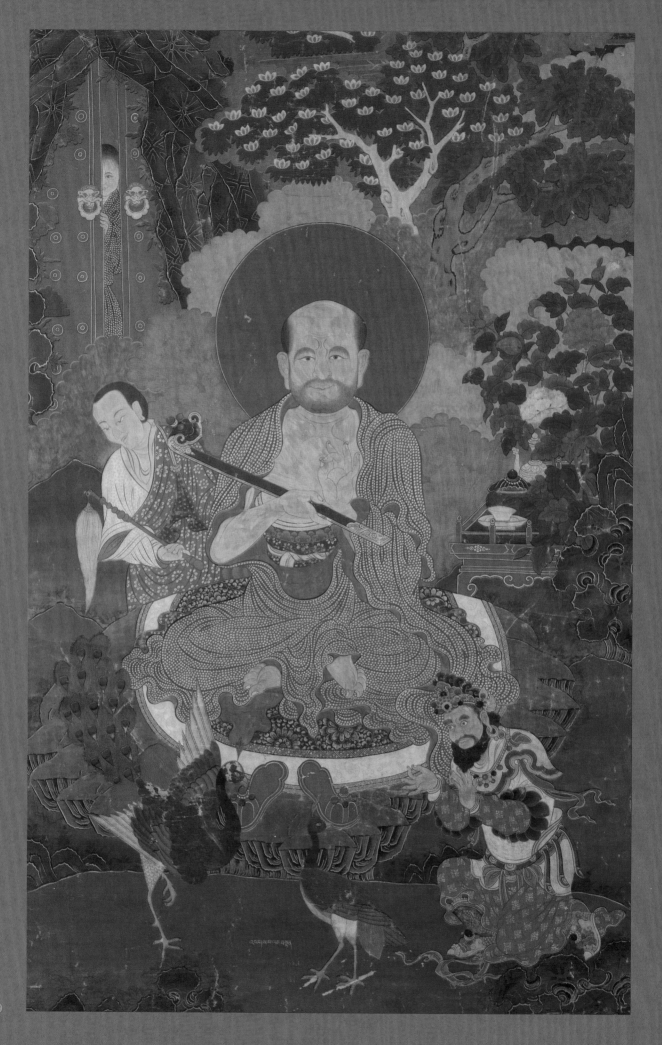

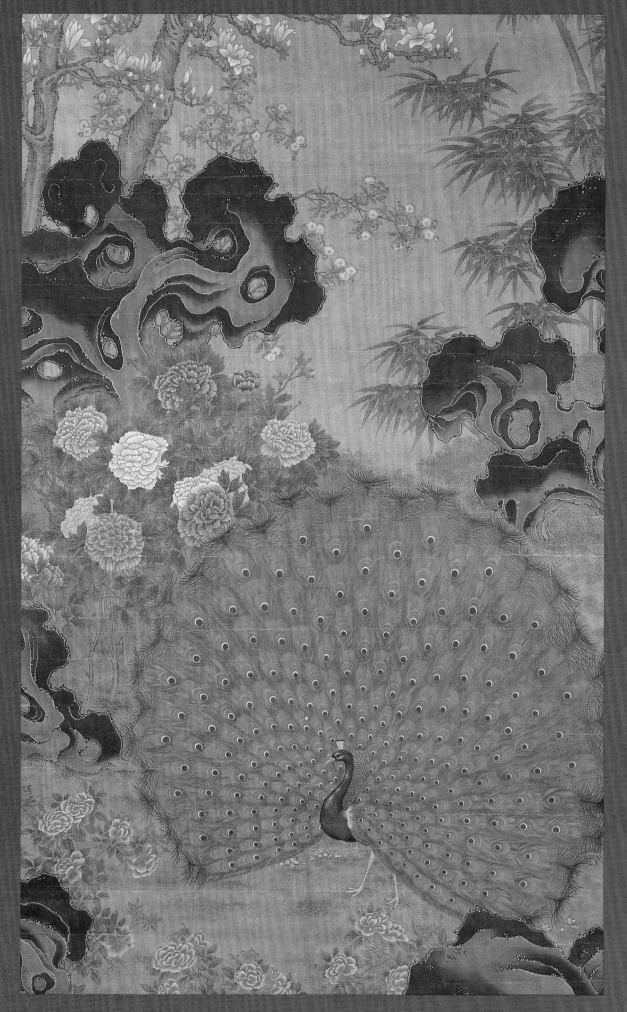

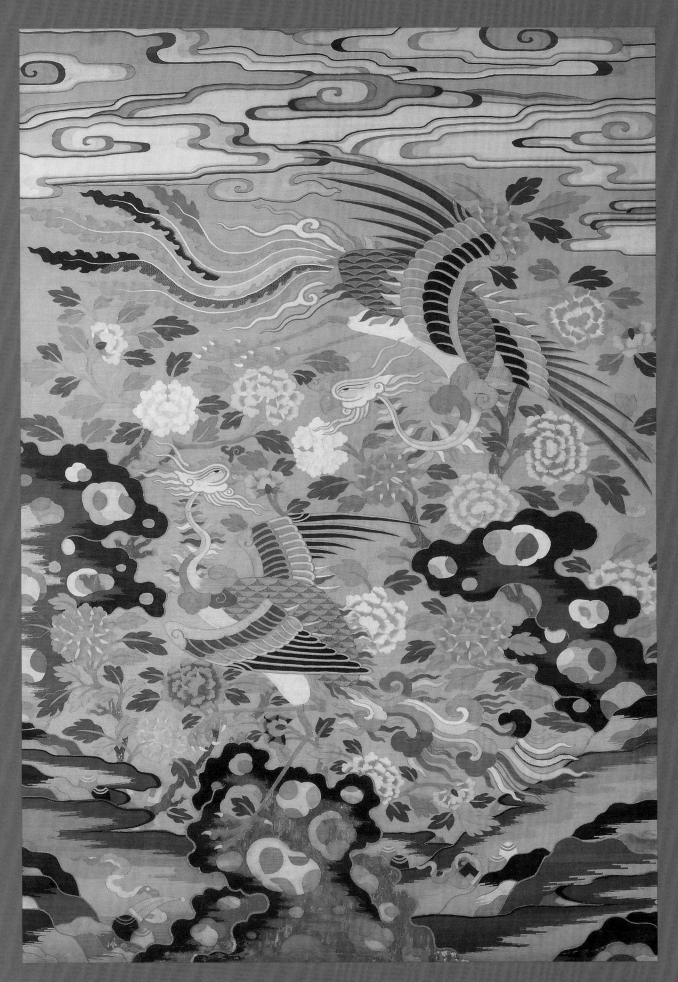

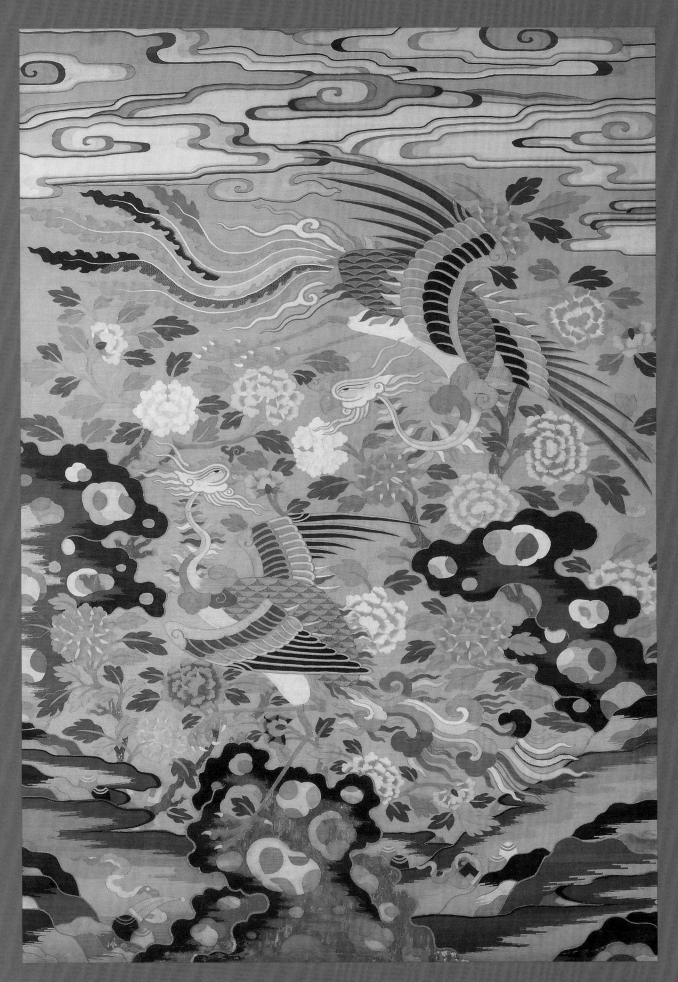

21

21

FENGHUANG (PHOENIX) PANEL
CHINA, 17TH CENTURY
POLYCHROME SILK AND
GOLD-FOIL-WRAPPED SILK, *KESI*
73¾ × 53 IN. (187.3 × 134.6 CM)
THE NEWARK MUSEUM

The Fenghuang is a pair of mythical composite birds, which are commonly called phoenixes. The *feng* is the male, and the *huang* the female. Since the *feng* usually has an uneven number of trailing tail feathers, it can be identified as the slightly larger upper bird still in flight. The *huang* has more curling, symmetrical tail feathers. She perches on one of three foraminate, honeycombed rocks, two blue and one now dark brown. The cavities in the rocks are particularly large, which gives a playful three-dimensional volume by creating the illusion that one can see into and through them. Large peony blossoms bend from thick stems and suggest a perfumed atmosphere. Filmy clouds enclose the composition at the top.

More than ten different colors of silk were woven into the panel, along with gold foil on paper twisted on silk thread.[1] The colors have faded unevenly but must originally have been as brilliant as those of a *kesi* preserved in a monastery in Tibet and illustrated in figure 26. Technically, *kesi* is slit weave tapestry, with slits created along every color change when wefts return. These slits are then joined with a stitch here and there. Unlike most woven textiles, *kesi* results in an identical finished pattern on both sides, though naturally the image is reversed. This explains why figure 26 is so close to the Newark *kesi*, except for the orientation of the composition. Like all fine Chinese textiles, *kesi* were prized in Tibet and used in religious contexts as banners, canopies, throne backs, and the like. Their patterns, like this one, would have helped to transmit a vocabulary of auspicious motifs later applied by Tibetan artists to the theme of the Arhat.

The most highly prized of all Chinese textiles was the kesi, *which rivals painting in subtleties of modulated color without painting's vulnerability to moisture and creasing.*

[1] Valrae Reynolds and Yen Fen Pei, *Chinese Art from the Newark Museum* (New York: China Institute in America, 1980), p. 49, no. 27.

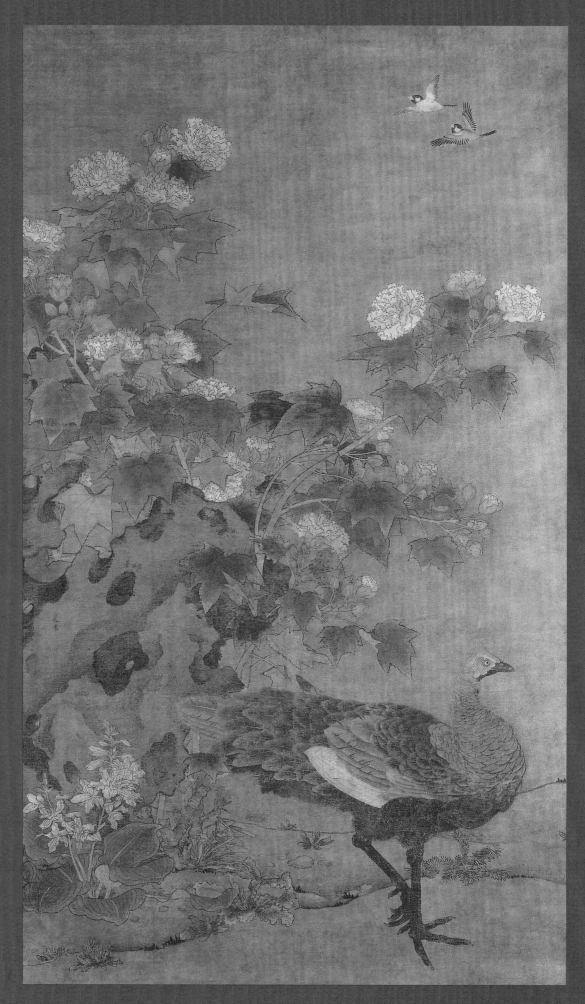

22

PEACOCK AND HOLLYHOCKS
BIAN LU
CHINA, MID-14TH CENTURY
HANGING SCROLL,
INK AND COLOR ON SILK
66¾ × 40½ IN. (170 × 102.3 CM)
THE METROPOLITAN MUSEUM OF ART,
NEW YORK

Pausing as it struts stiffly out from tall stalks of hollyhocks, the peacock stares intently ahead, keeping his head up and crest vertical. Behind him is a perforated garden rock, like the type already found in imperial gardens by the early twelfth century (see essay, section 4). Either the peacock is young, without the full train that maturity brings, or his tail feathers have molted, which typically occurs after breeding season.[1] In that case, the scene may represent late summer, when hollyhocks are still blooming. The leaves of the hollyhock are artfully arranged to contrast the different green shades of the tops and undersides, almost as if a breeze is turning them. A pair of small birds darts away from whatever has caught the peafowl's attention. Bian Lu's painting is a particularly fine example of accomplished bird-and-flower painting combining close observation of nature with ripe sensual beauty.

This intimate view of a corner of a garden is a precedent for the later Arhat paintings that feature peacocks, flowers, and foraminate rocks. In the early Ming, when Tibetan monks and teachers were invited to the court, they must have been exposed to such favored works of art, hung in palaces and mansions, and no doubt they brought some back to Tibet upon their return as part of an exchange of gifts.

Like rulers everywhere, Chinese emperors delighted in receiving tributary gifts of animals from foreign lands and placing them in the imperial garden preserve, along with exotic rocks and scented flowers.

[1] See Craig Hopkins, "Peafowl: Family Phasianidae," www.peafowl.org/ARTICLES/14.

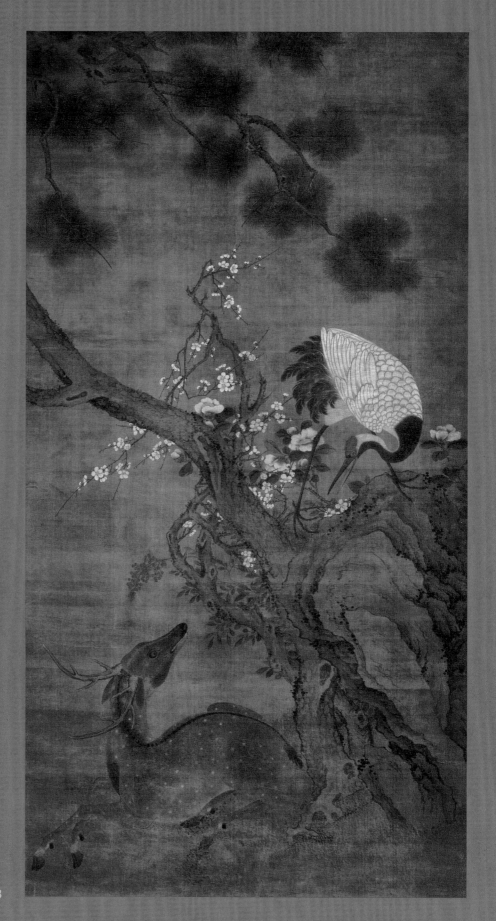

23

MANCHURIAN CRANE, DEER, PINE, PLUM, ROCKS, AND FLOWERS
ATTRIBUTED TO WU WEIQIAN
CHINA, MING DYNASTY, CA. 16TH CENTURY
HANGING SCROLL, COLORS ON SILK
70 × 37¼ IN. (177.7 × 94.2 CM)
PRINCETON UNIVERSITY ART MUSEUM

This is a fine silk hanging scroll, of the type favored at the Ming court.[1] The deft application of opaque pigments for the crane and flowers, including a scarlet red for the crane's crown and the smallest flowers, contrasts with the very loose wet-ink of the rock and tree trunk. The Manchurian crane and the antlered deer are diagonally paired, their eyes locked across a dramatically angled tree trunk. What appears as a completely natural moment in the midst of forest or marshland is actually a very tightly organized, interlocking composition. The crane appears to have come upon a deer sheltering peacefully by a large rock, old pine, and new spring blossoms. The artist has portrayed the Manchurian crane in mid-cry. The distinctive call of this species can be heard for hundreds of meters, and here it seems to harshly express its annoyance at the presence of the deer. The deer watches the crane warily but is unperturbed.

All the elements of the painting—the rock, the pine tree, the crane, the deer, and the plum—carry associations of longevity in Chinese culture (see essay, sections 3 and 4). The extraordinary access the artist seems to give the viewer, as if an invisible witness to the daily dramas of the natural world, is the rarest of vistas. Only the immortals are likely to stumble on such an auspicious conjunction, which is of course what the painting is meant to convey.

Cranes are deeply resonant in Chinese culture as auspicious portents and harbingers of longevity, it being believed that they could live for hundreds of years.

[1] Compare Palace Museum, *A Selection of Ming Dynasty Court Paintings and the Zhe School Paintings* (Beijing: Cultural Relics Publishing, 1983), nos. 5, 6, 23, 37, 41, etc.

[1] In catalog no. 24, Tibetan inscription: g.yon lnga pa sgra can 'dzin.
 Rahula was the son and disciple of the Buddha. He is the tenth Arhat in the Tibetan set; the eleventh according to Nandimitra (see essay, section 1).

[2] For example, the sixth-century panel from a sarcoph-agus, the painting "Immortal Riding a Dragon," and the "Taoist Official of Water," in Stephen Little and Shawn Eichman, *Taoism and the Arts of China* (Chicago: Art Institute of Chicago, 2000), nos. 10, 28, 71. The bearded, burly warrior type is shared by celestial generals and gods' attendants found in paintings of Daoist celestials; ibid., nos. 57, 71.

[3] The curling spray foaming from the waves of the river demonstrates knowledge of Chinese water painting con-ventions. Compare Palace Museum, *A Selection of Ming Dynasty Court Paintings and the Zhe School Paintings* (Bei-jing: Cultural Relics Publish-ing, 1983), nos. 17, 19.

[4] See Gisèle Croës, *Splendor of Yongle Painting: Portraits of Nine Luohan* (Brussels, 2002), no. 9.

24

ARHAT: RAHULA
CHINA? CA. 16TH CENTURY
MINERAL PIGMENTS ON CLOTH
31½ × 18½ IN. (80 × 47 CM)
RUBIN COLLECTIONS

25

RAHULA
TIBET, CA. 15TH CENTURY
MINERAL PIGMENTS ON CLOTH
40½ × 24 IN. (102.9 × 61 CM)
COLLECTION OF NAVIN KUMAR,
NEW YORK

This pair of paintings depicts the Arhat Rahula.[1] The diadem he holds refers to the crown the gods presented him in thanks for his preaching the Buddhist doctrines in the heaven of thirty-three gods. In both paintings, a deer lies placidly in front of the cloth-covered rock on which Rahula sits. The Arhat's sandals are untied and removed. Under his red outer wrap is a rich green robe, and he has a slight smile.

Details of the posture, dress, sandals, and deer in the two paintings are nearly identi-cal, indicating a common model. However, the attendants are quite different. In the Rubin painting (cat. no. 24), a burly god grips the horns of a writhing dragon, which seems to be swooping into the picture trail-ing its own cloud. A long slender pheasant feather is attached to the attendant's cap, while a book for the Arhat is strapped to his back. He resembles one of the folk gods of China, where heavenly dragon-riders are common.[2] Rustic in appearance, the young attendant in the Kumar painting also pre-sents the Arhat with a book, standing calmly before him.

The two most significant differences between the paintings are the landscape set-ting and the brushwork. The Rubin paint-ing is an open composition, and one can see beyond Rahula into a distant vista of a river, hills, and gold-outlined mountains. A large white bird appears to chase the clouds scud-ding across the sky. The painting is much more "inky" than most Tibetan paintings. Not only do the lines thicken and thin, but there are transparent ink washes deftly applied in a Chinese brush manner.[3] A com-parison of the two paintings shows that the Rubin painter had a better, more detailed understanding of the anatomy of deer, as demonstrated in the curved lines of the bent neck and in the hair lining the ears.

The Kumar painting is both more Tibetan in its handling of forms and more faithful to the Rahula composition found in the early fifteenth-century Chinese set.[4] The brush control in the tree branches is close to Chinese models. Elsewhere, lines carefully outlining each shape are more even in width than in the Chinese work, recalling Tibetan underdrawing. Some end in awkward hooks, as if artists were copying without quite understanding Chinese brushwork. This seems to suggest a less painterly attitude, less of a willingness to allow uneven dots of color to resolve into trees or bushes. The colors are as saturated as in the fifteenth-century set and more luminous than in the Rubin painting. The most striking difference in the Kumar painting, however, is the insertion of a seated Buddha at the top center of the composition. He is unquestionably rendered to a Tibetan iconometric standard. The lines radiating from him in the nimbus alternate the intensity of their oscillation in a pattern familiar in Tibetan painting. Additionally, this artist used a cotton ground, much more common in Tibet than in China. Clearly, this artist was familiar with Chinese painting methods and worked from a model deriving from the early fifteenth-century set.

It is more difficult to determine the ori-gin of the Rubin painting. Although either a Tibetan or a Chinese provenance is possible, with so many elements revealing more than a passing acquaintance with Chinese reli-gious and landscape painting, Chinese seems more likely.

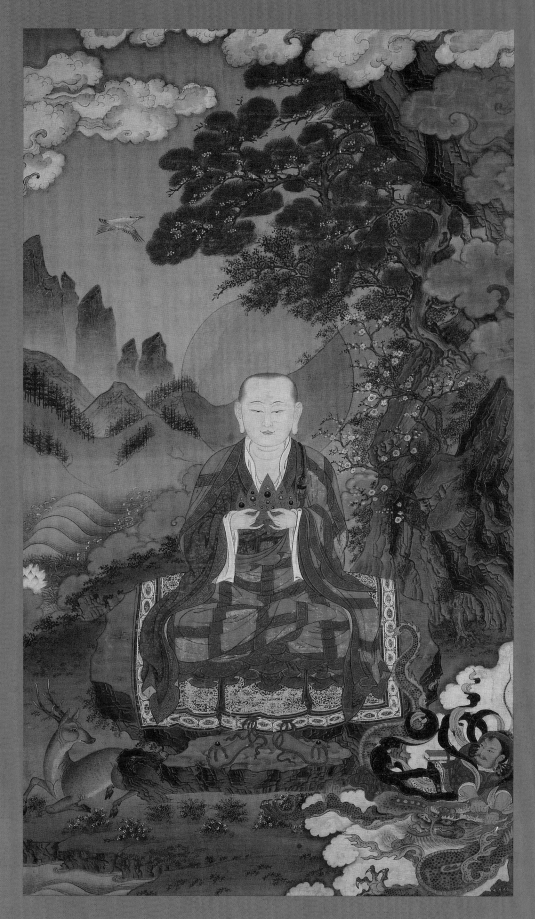

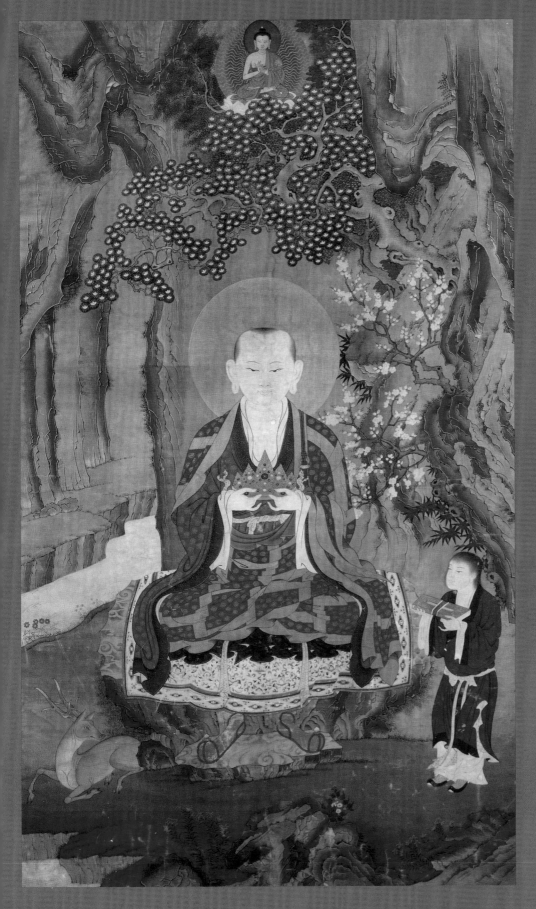

*Even as we are
attentive to the
dependence of
Tibetan artists
on Chinese art for
the compositions,
it is very instruc-
tive to notice what
the Tibetans add,
subtract, and
transform.*

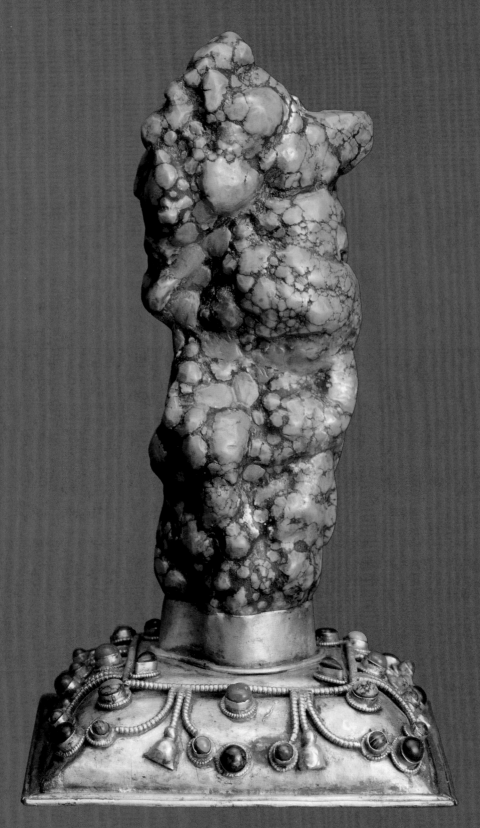

26

26

TREASURE OFFERING
TIBET, NOT DATED
TURQUOISE TREASURE OFFERING
HT. 8½ IN. (21.6 CM) INCLUDING BASE
COLLECTION OF JOHN AND BERTHE FORD,
BALTIMORE

In Tibetan culture, turquoise plays a large, conspicuous role, as jade does in China. Turquoise appears in many literary metaphors to suggest value, and families store wealth through accumulations of turquoise stones sewn into headdresses and worn by married women on ritual occasions. Monasteries also receive turquoise stones as offerings, inlaying them, along with coral and other precious objects, into metal reliquaries (essay, figs. 20, 21).

This stone's dark matrix outlines boulder-shaped protrusions on the surface. The turquoise has been polished and slightly rounded, but its natural irregularities have been preserved. A specially made gilt-metal base was designed with swags of pearls and bells and inset cabochon beads of coral, turquoise, and lapis lazuli. The upright stone resembles a miniature cliff or mountain. It appears to be a Tibetan version of a Chinese scholars' rock and was no doubt placed in a shrine or monastery as a "treasure offering" to the Buddha.

Certainly an Arhat or Lama appreciates and deserves the finest treasures, just as the mandala-offering stipulates coral and turquoise.

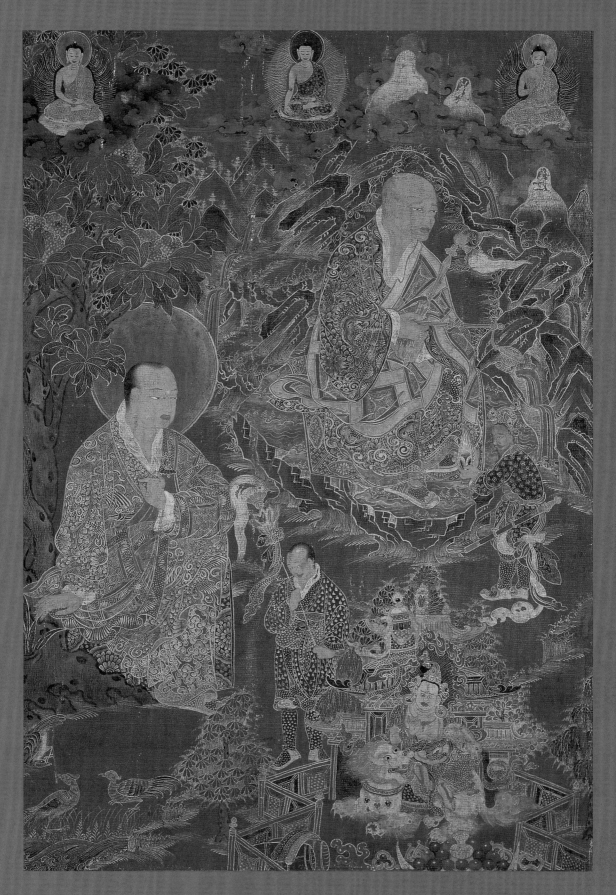

27

TWO ARHATS WITH VAISHRAVANA
RIDING A LION
TIBET, 17TH CENTURY
MINERAL PIGMENTS AND GOLD ON CLOTH
24½ × 17¼ IN. (62 × 44 CM)
COLLECTION OF NAVIN KUMAR,
NEW YORK

The Arhat on the right, holding a fly whisk and long-handled censer, is Angaja, the first Arhat in the Tibetan system and thirteenth in Nandimitra's text (see essay, section 1). The two objects he holds were given to him by divine beings so he could cool himself and meditate deeply. Angaja is shown with a kingly figure in attendance, offering him a radiant gem. The other Arhat has not yet been identified definitively but might be Vajriputra or possibly Gopaka. His attendant wields a staff with a fly whisk on it, with bright feathers where the fly whisk attaches to the handle. At the bottom, the protector Vaishravana rides a lion and cradles a jewel-spitting mongoose. He is enclosed by a cinnabar-lacquer balustrade leading to a palace with three levels of upturned eaves. Three of the Thirty-five Buddhas of Confession float above the Arhats.[1]

The red color of the background connects this painting to a distinctly Tibetan style of painting known as red-ground, or *tsal-tang*. The flattened treatment of space, radiant colors, and Buddha figures at the top are typical Tibetan features. However, many of the details of the brocade patterns, intertwined tree trunks, and blue-and-green-style rocks echo Chinese paintings. A second painting in the same collection was recently published (see essay, section 12).[2]

It is almost as if the Tibetan artist has exposed Chinese blue-and-green rocks to radioactive light, transforming the colors into yellow-red-blue-and-green.

[1] I am grateful to Jeff Watt, director of the Himalayan Art Website, for pointing this out to me.

[2] Pratapaditya Pal, *Himalayas: An Aesthetic Adventure* (Chicago: Art Institute of Chicago, 2003), no. 170.

Appendix

The following eighteen paintings belong to the same set, created in Tibet in the seventeenth century. Twelve of the original sixteen Arhat paintings are represented here, along with both attendants (Dharmatala and Hvashang) and all four Direction Guardians. Originally there would have been at least twenty-three paintings in the set, with a Buddha Shakyamuni as the central painting. According to Mr. Navin Kumar, the Buddha Shakyamuni painting from this set is in a private collection in New York but is in too poor a condition to reproduce. The paintings would have been hung with the Buddha Shakyamuni painting in the center and Arhats to left and right, arranged so that each Arhat looked toward the center. The two attendants would have been at either end, with a pair of Direction Guardians at the outermost positions on each side.

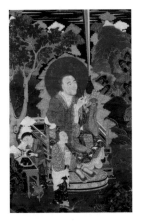

1

Ajita, Arhat (Elder)
Tibet, 17th century
Mineral pigments on cloth
38 × 23½ in.
(96.5 × 59.7 cm)
Rubin collections,
New York
P1994.10.15 (HAW 168)

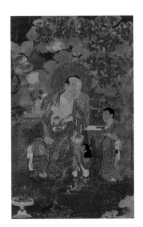

4

Kanakavatsa, Arhat (Elder)
Tibet, 17th century
Mineral pigments on cloth
37 × 23 in.
(94 × 58.42 cm)
Rubin collections,
New York
P1990.1.1 (HAW 33)

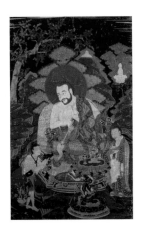

2

Vanavasin, Arhat (Elder)
Tibet, 17th century
Mineral pigments on cloth
38¼ × 24 in.
(97.2 × 61 cm)
Rubin collections,
New York
F1996.22.2 (HAW 480)

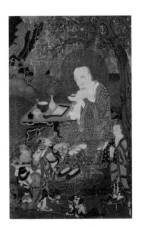

5

**Kanakabharadvaja, Arhat
(Elder)**
Tibet, 17th century
Mineral pigments on cloth
36½ × 23¾ in.
(92.7 × 60.3 cm)
Rubin collections,
New York
P1990.1.2 (HAW 34)

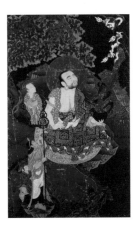

3

Vajriputra, Arhat (Elder)
Tibet, 17th century
Mineral pigments on cloth
38 × 24 in.
(96.5 × 61 cm)
Collection of Navin Kumar,
New York
(HAW 90021)

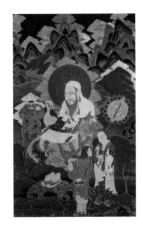

6

Bakula, Arhat (Elder)
Tibet, 17th century
Mineral pigments on cloth
37½ × 23½ in.
(95.3 × 59.7 cm)
Rubin collections,
New York
P1991.1.2 (HAW 166)

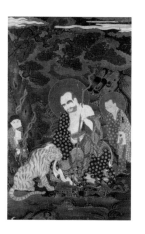

7

Rahula, Arhat (Elder)
Tibet, ca. 17th century
Mineral pigments on cloth
37½ × 23½ in.
(95.3 × 59.7 cm)
Rubin collections,
New York
P1996.9.3 (HAW 245)

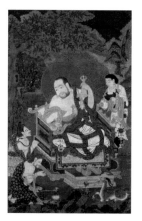

8

**Pindola Bharadvaja, Arhat
(Elder)**
Tibet, 17th century
Mineral pigments on cloth
36½ × 22¾ in.
(92.7 × 57.8 cm)
Rubin collections,
New York
P1996.9.6 (HAW 389)

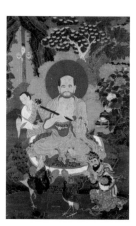

9

Pantaka, Arhat (Elder)
Tibet, ca. 17th century
Mineral pigments on cloth
37½ × 23½ in.
(95.3 × 59.7 cm)
Rubin collections,
New York
P1996.9.2 (HAW 243)

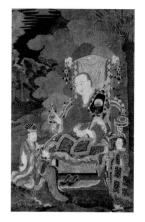

10

Arhat (Elder)
Tibet, 17th century
Mineral pigments on cloth
36½ × 22¾ in.
(92.7 × 57.8 cm)
Rubin collections,
New York
P1996.9.4 (HAW 246)

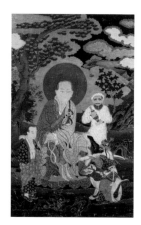

11

**Chudapantaka, Arhat
(Elder)**
Tibet, 17th century
Mineral pigments on cloth
38 × 25 in.
(96.5 × 63.5 cm)
Rubin collections,
New York
P1991.1.1 (HAW 165)

12

Abheda, Arhat (Elder)
Tibet, 17th century
Mineral pigments on cloth
38 × 24 in.
(95.5 × 61 cm)
Collection of Navin Kumar,
New York
(HAW 90026)

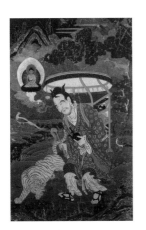

13

Dharmatala, Attendant to the sixteen Arhats
Tibet, 17th century
Mineral pigments on cloth
38 × 24 in.
(96.5 × 61 cm)
Rubin collections,
New York
P1994.10.12 (HAW 158)

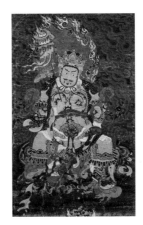

16

Vaishravana, Direction Guardian of the north
Tibet, 17th century
Mineral pigments on cloth
37½ × 23½ in.
(95.3 × 59.7 cm)
Rubin collections,
New York
P1995.15.2 (HAW 144)

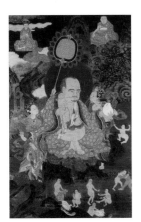

14

Hvashang, Attendant to the sixteen Arhats
Tibet, 17th century
Mineral pigments on cloth
37¾ × 23 in.
(95.9 × 58.4 cm)
Rubin collections,
New York
P1996.9.1 (HAW 241)

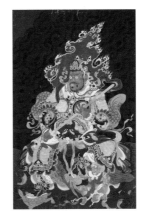

17

Virudhaka, Direction Guardian of the south
Tibet, 17th century
Mineral pigments on cloth
37¾ × 24 in.
(95.9 × 61 cm)
Rubin collections,
New York
F1997.11.3 (HAW 172)

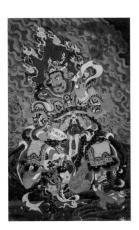

15

Virupaksha, Direction Guardian of the west
Tibet, 17th century
Mineral pigments on cloth
37¾ × 23½ in.
(95.9 × 59.7 cm)
Rubin collections,
New York
P1995.15.1 (HAW 143)

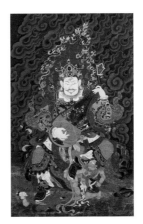

18

Dhritarashtra, Direction Guardian of the east
Tibet, 17th century
Mineral pigments on cloth
37¾ × 24 in.
(95.9 × 61 cm)
Rubin collections,
New York
F1997.11.4 (HAW 177)

Exhibition Checklist

Note: Objects shown in only one of the two venues are indicated below with the following key: RMA, Rubin Museum of Art, New York; and Tang, Frances Young Tang Teaching Museum and Art Gallery, Skidmore College, Saratoga, New York.

Note: Fractions to the nearest ¼; decimals to the nearest one place.

1. TWO LOHANS AND ATTENDANT
CHINA, SOUTHERN SONG DYNASTY, 13TH CENTURY
HANGING SCROLL,
INK AND PIGMENTS ON SILK
43½ × 21¼ IN. (111.1 × 54 CM)
PRIVATE COLLECTION
EXHIBITED AT RMA ONLY

2. LOHAN CUTTING TOENAILS
ATTRIBUTED TO CAI SHAN
CHINA, 13TH–14TH CENTURY
HANGING SCROLL, INK ON SILK
46 × 18 IN. (117 × 46 CM)
KAIKODO, NEW YORK

3. ARHAT: RAHULA
TIBET, CA. 17TH CENTURY
MINERAL PIGMENTS ON CLOTH
37½ × 23½ IN. (95.3 × 59.7 CM)
RUBIN COLLECTIONS
ACC. NO. P1996.9.3 (HAW 245)

4. ARHAT: AJITA
CHINA, YONGLE PERIOD, 1402–24
MINERAL PIGMENTS AND GOLD ON SILK
30¾ × 19¾ IN. (78 × 50 CM)
COLLECTION OF ROBERT ROSENKRANZ, NEW YORK
EXHIBITED AT RMA ONLY

5. ARHAT: CHUDAPANTAKA
TIBET, LATE 15TH CENTURY
MINERAL PIGMENTS ON CLOTH
39 × 22½ IN. (99 × 57.2 CM)
RUBIN COLLECTIONS
ACC. NO. C2003.50.3 (HAW 129)
EXHIBITED AT RMA ONLY

6. ARHAT: KALIKA
CHINA, YONGLE PERIOD, 1402–24
PRODUCED IN THE IMPERIAL WORKSHOPS OF THE MING COURT
MINERAL PIGMENTS AND GOLD ON SILK
30¾ × 19¾ IN. (78 × 50 CM)
COLLECTION OF ROBERT ROSENKRANZ, NEW YORK
EXHIBITED AT TANG ONLY

7. ARHAT: KALIKA
TIBET, CA. 15TH CENTURY
MINERAL PIGMENTS ON CLOTH
46¾ × 29¼ IN. (118.8 × 74.3 CM)
RUBIN COLLECTIONS
ACC. NO. P1994.10.8 (HAW 35)
EXHIBITED AT TANG ONLY

8. PORTRAIT OF LU WENDING
SHEN JUN
CHINA, 1591 (19TH YEAR OF WANLI)
ONE OF TEN LEAVES CUT FROM HANDSCROLL AND REMOUNTED AS ALBUM, COLORS ON SILK
SILK LEAF: 12½ × 14½ IN. (31.6 × 36.8 CM)
PRINCETON UNIVERSITY ART MUSEUM
GIFT OF J. LIONBERGER DAVIS, CLASS OF 1900
ACC. NO. PUAM Y1996-101 A–K

9. ARHAT: KALIKA
TIBET, CA. 18TH CENTURY
MINERAL PIGMENTS ON CLOTH
21¼ × 15¼ IN. (54 × 38.7 CM)
RUBIN COLLECTIONS
ACC. NO. P2000.5.4 (HAW 948)

10. INCENSE STAND (XIANGJI)
SUZHOU, CHINA, 16TH–17TH CENTURY
NANMU WOOD
HT. 32½ IN. (82.6 CM)
CHAMBERS FINE ART, NEW YORK

11. TRIPOD CENSER
CHINA, JIN DYNASTY, 1115–1234
STONEWARE, GLAZE
6¾ × 6¾ IN. (17.1 × 16.8 CM)
BROOKLYN MUSEUM OF ART
GIFT OF ALAN AND SIMONE HARTMAN
1991.127.1

12. TREE
CHINA, 19TH CENTURY
NATURAL CORAL
HT. 30¼ × 14 × 8 IN. (76.5 × 35.5 × 20.3 CM)
BROOKLYN MUSEUM OF ART
GIFT OF MR. AND MRS. NAT BASS
ACC. NO. 77.53

13. ARHAT: ABHEDA
TIBET, CA. 16TH CENTURY
MINERAL PIGMENTS ON CLOTH
32 × 20 IN. (81.3 × 50.8 CM)
RUBIN COLLECTIONS
ACC. NO. F1996.4.1 (HAW 409)

14. BLUE-AND-WHITE HU VESSEL WITH RING HANDLES
PORCELAIN VASE IN THE FORM OF AN ARCHAIC BRONZE
CHINA, MING DYNASTY, WANLI ERA, 1578–1619
PORCELAIN, UNDERGLAZE
8 × 4 × 4 IN. (20.3 × 10 × 10 CM)
BROOKLYN MUSEUM OF ART
THE WILLIAM E. HUTCHINS COLLECTION, BEQUEST OF AUGUSTUS S. HUTCHINS
ACC. NO. 52.49.20

15. ARHAT: KANAKAVATSA
TIBET, CA. 17TH CENTURY
MINERAL PIGMENTS ON CLOTH
37 × 23 IN. (94 × 58.4 CM)
RUBIN COLLECTIONS
ACC. NO. P1990.1.1 (HAW 33)

16. SCHOLARS' ROCK
CHINA, NOT DATED
AZURITE WITH MALACHITE
HT. 7 IN. INCLUDING STAND (17.8 CM)
COLLECTION OF TRAVIS A. KERR

17. ARHAT: KANAKABHARADVAJA
EASTERN TIBET, 18TH CENTURY,
MINERAL PIGMENTS ON CLOTH
31 × 21 IN. (78.7 × 53.3 CM)
RUBIN COLLECTIONS
ACC. NO. F1997.17.16 (HAW 333)

18. ROCK MOUNTAIN
CHINA, LATE MING OR EARLY QING DYNASTY, 1368–1644
STEATITE
15¾ × 10 IN. (40 × 25.5 CM)
HEIGHT WITH STAND 17.5 IN. (45.1 CM)
BROOKLYN MUSEUM OF ART
DESIGNATED PURCHASE FUND
ACC. NO. 86.5

19. ARHAT: PANTAKA
TIBET, CA. 17TH CENTURY
MINERAL PIGMENTS ON CLOTH
37½ × 23½ IN. (95.3 × 59.7 CM)
RUBIN COLLECTIONS
ACC. NO. P1996.9.2 (HAW 243)

20. PEACOCK WITH FLOWERS AND FANTASTIC ROCKS
CHINA, QING DYNASTY, 17TH CENTURY
HANGING SCROLL, INK AND COLORS ON SILK
53¾ × 34 IN. (136.5 × 86.5 CM)
MINNEAPOLIS INSTITUTE OF ARTS, GIFT OF RUTH AND BRUCE DAYTON
ACC. NO. 2002.4.6

21. FENGHUANG (PHOENIX) PANEL
CHINA, 17TH CENTURY
POLYCHROME SILK AND GOLD-FOIL-WRAPPED SILK, KESI
73¾ × 53 IN. (187.3 × 134.6 CM)
THE NEWARK MUSEUM
THE COLLECTION OF THE NEWARK MUSEUM, GIFT OF HERMAN AND PAUL JAEHNE
ACC. NO. JAEHNE COLLECTION (39.371)

22. PEACOCK AND HOLLYHOCKS
BIAN LU
CHINA, MID-14TH CENTURY
HANGING SCROLL, INK AND COLOR ON SILK
66¾ × 40½ IN. (170 × 102.3 CM)
THE METROPOLITAN MUSEUM OF ART, NEW YORK
THE DILLON FUND AND THE B.Y. LAM FOUNDATION GIFTS, 1995
ACC. NO. 1995.186

23. MANCHURIAN CRANE, DEER, PINE, PLUM, ROCKS, AND FLOWERS
ATTRIBUTED TO WU WEIQIAN
CHINA, MING DYNASTY, CA. 16TH CENTURY
HANGING SCROLL, COLORS ON SILK
69¼ × 36¾ IN. (176 × 93 CM)
PRINCETON UNIVERSITY ART MUSEUM
DUBOIS SCHANK MORRIS COLLECTION
ACC. NO. PUAM 47-231

24. ARHAT: RAHULA
CHINA, CA. 16TH CENTURY
MINERAL PIGMENTS ON CLOTH
31½ × 18½ IN. (80 × 47 CM)
RUBIN COLLECTIONS
ACC. NO. F1997.17.15 (HAW 332)

25. RAHULA
TIBET, CA. 15TH CENTURY
MINERAL PIGMENTS ON CLOTH
40½ × 24 IN. (102.9 × 61 CM)
COLLECTION OF NAVIN KUMAR, NEW YORK

26. TREASURE OFFERING
TIBET, NOT DATED
TURQUOISE TREASURE OFFERING
HT. 8½ IN. (21.6 CM) INCLUDING BASE
COLLECTION OF JOHN AND BERTHE FORD, BALTIMORE

27. TWO ARHATS WITH VAISHRAVANA RIDING A LION
TIBET, 17TH CENTURY
MINERAL PIGMENTS AND GOLD ON CLOTH
24½ × 17¼ IN. (62 × 44 CM)
COLLECTION OF NAVIN KUMAR, NEW YORK